Contents

ISBN

978 1445 68 42 39

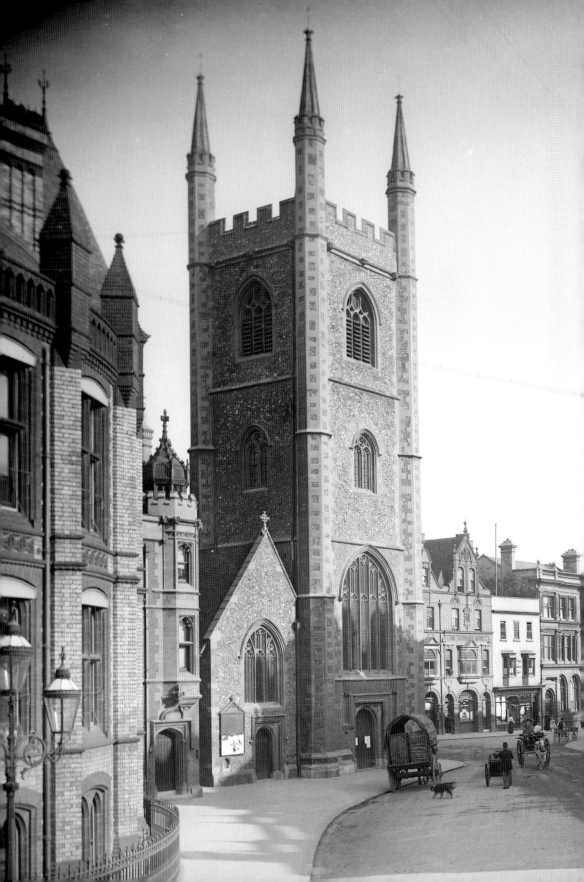

Introduction

Reading has a fascinating history that stretches back many centuries. A twentieth-century excavation exposed a large Bronze Age settlement. The Romans took up residence during the first century, but it was not until the seventh century that a red-headed resident named Reada gave his name to the town. Situated between the two kingdoms of Wessex and Mercia, Reading soon became an area of conflict.

The Vikings invaded in the ninth century but were eventually defeated in AD 871 by the Saxon King Alfred. Sporadic raids on Reading and other towns took place early in the following century and by 1017 they had control of the whole country. King Canute put his standard bearer Tovi in charge of the town of Reading.

By the time William the Conqueror invaded in 1066, Reading had grown to be an important town that merited a mention in the Domesday Book of 1086. In it there was mention of a church, which was probably on the site of the present St Mary's.

Christianity played an important part in medieval England. In 1121 Henry I laid the foundation stone of Reading Abbey, which was to dominate the town until its dissolution by Henry VIII in the sixteenth century. Over the centuries Reading became an important centre. Its population doubled, a Merchant Guild was established in the thirteenth century, new streets made transport easier, a marketplace was established and goods were transported to London on the River Kennet.

In 1542 Henry VIII's royal charter made Reading a borough. The town continued to thrive in spite of fighting in the streets during the Civil War and the 'Bloodless Revolution' (the Glorious Revolution of 1688). In the eighteenth century Reading made use of new technology, and by the end of that century it had a number of public houses. The brewing industry was thriving. In the nineteenth century the Quakers Huntley and Palmer established their biscuit factory and the Sutton family developed their horticulture business. In the eighteenth century Reading had embraced change: new forms of transport were introduced, schools were built and new businesses were created.

During the following century the borough weathered the two world wars and by the twenty-first century Reading had developed into a vibrant modern town, which continues to flourish.

Places of Worship

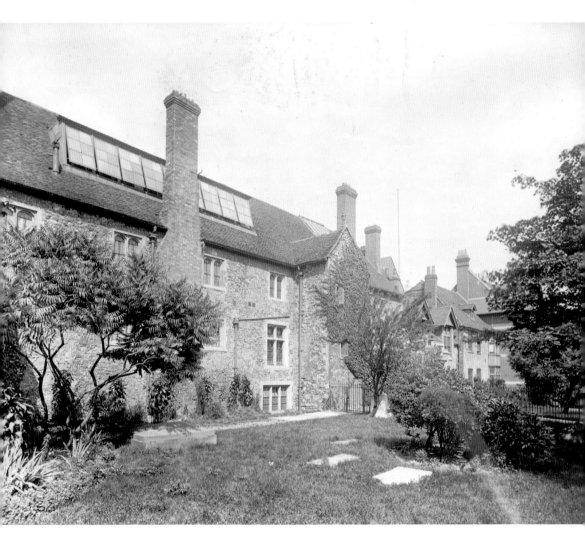

Above: Reading Abbey
In 1121 Henry I laid the foundation stone of Reading Abbey founded by the Cluniac order, which owned 30 acres of land. In 1164 the abbey church was consecrated by Thomas á Becket. It was the centre of a large community incorporating a leper house and a hospitum. Today it is part of the University of Reading. (Historic England Archive)

Opposite above: Greyfriars Church
In 1233 a group of Greyfriars monks arrived in Reading. They built a church on land near Caversham Bridge but a later church was built on the present site. In 1538 the monks left, the building was sold and later the church fell into disrepair. In 1863 it was restored and Greyfriars Church is still in use today. (Historic England Archive)

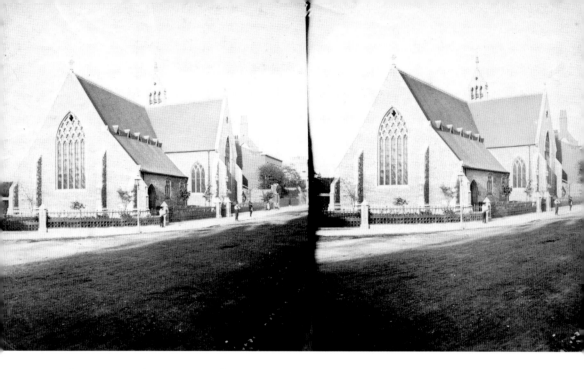

Below: Nineteenth-century Greyfriars
This photo was taken in 1875 by Henry W. Taunt. It shows the nineteenth-century Greyfriars Church, which was reconstructed by Woodman from the remains of the original thirteenth-century Franciscan church. It is now Grade I listed. (Historic England Archive)

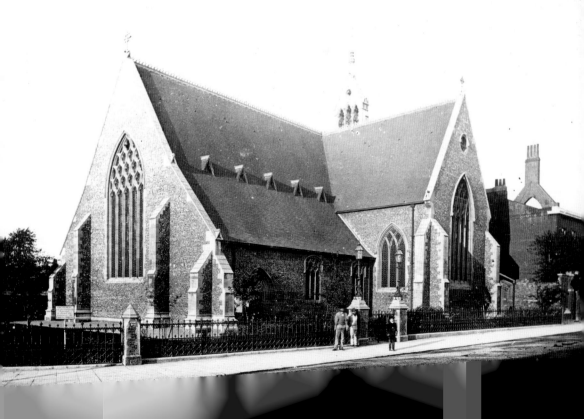

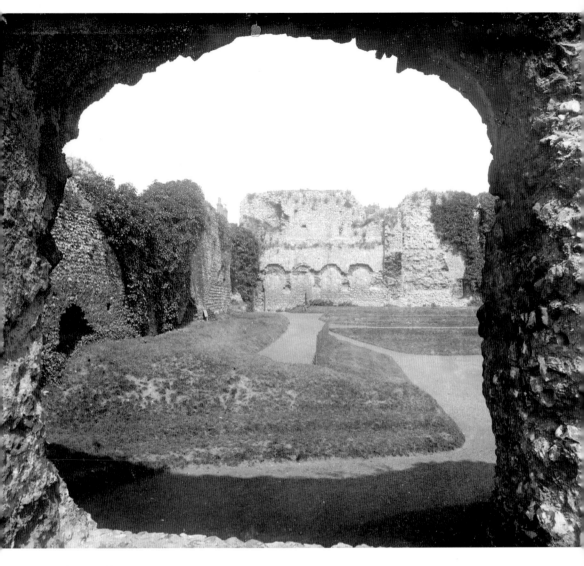

Above: Abbey Dormitory
The abbey dormitory can be seen through the ruins of the south wall of the Chapter House.
(Historic England Archive)

Opposite: Abbey Gate
After the dissolution of Reading Abbey in the sixteenth century, its treasures were looted, the lead on the roof was stripped and its building materials were dispersed around the country leaving the abbey a ruin. However, part of the the abbey gate remained. The latter was remodelled by Sir George Gilbert Scott in 1861. (Historic England Archive)

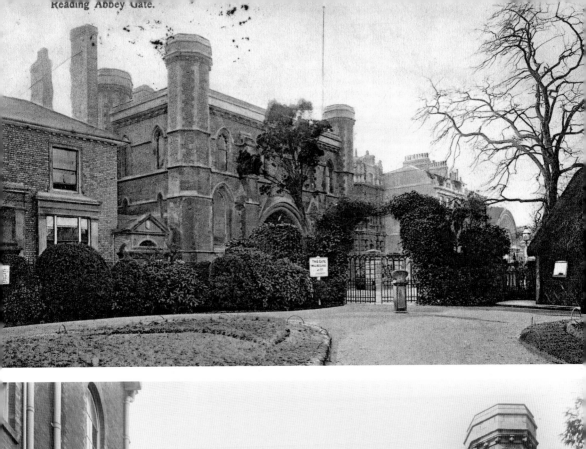

Reading Abbey Gate.

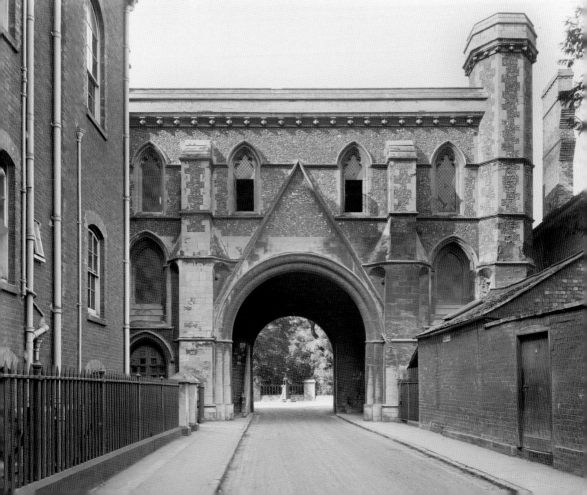

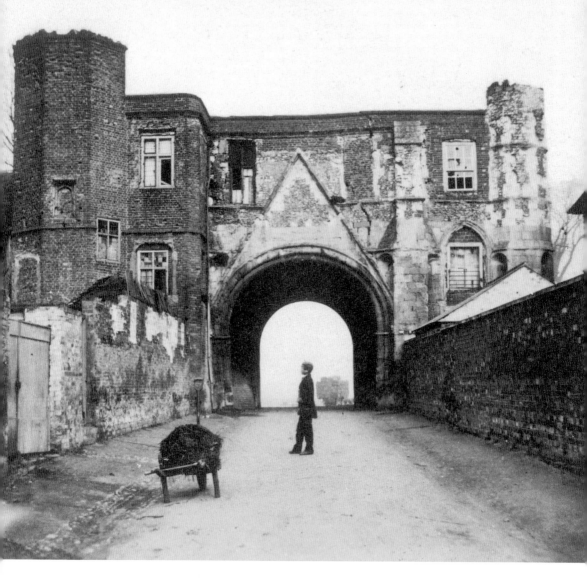

Above: Reading Abbey Gateway
This photo, taken in the late nineteenth century, shows the exterior of the Abbey Gateway in
The Forbury. (Historic England Archive)

Opposite above: Abbey Ruins
This photograph shows the remains of the abbey dormitory and the south wall of the Chapter
House. It was taken by the photographer Henry W. Taunt. (Historic England Archive)

Opposite below: Panelling
This elaborately carved linenfold panelling is now in the Great Hall of Magdalen College,
University of Oxford. Tradition has it that it was brought from Reading Abbey after the
Dissolution of the Monasteries. (Historic England Archive)

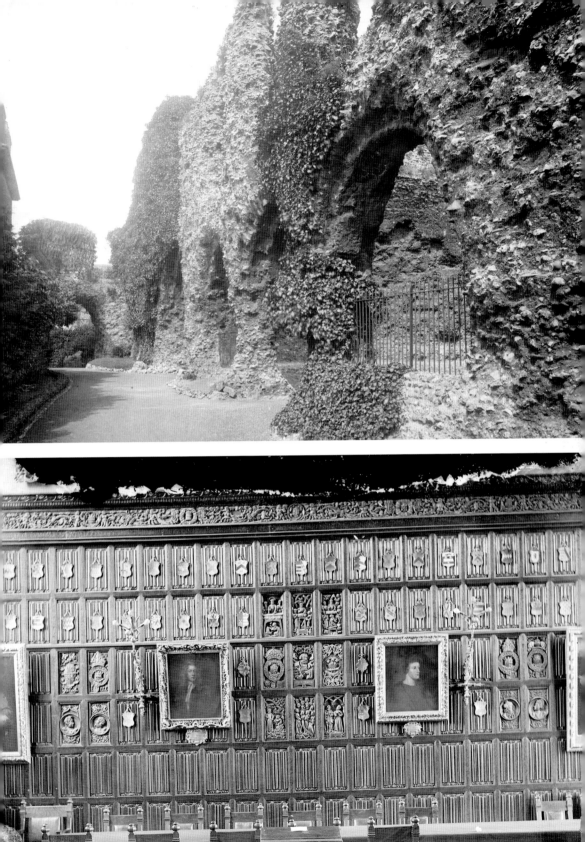

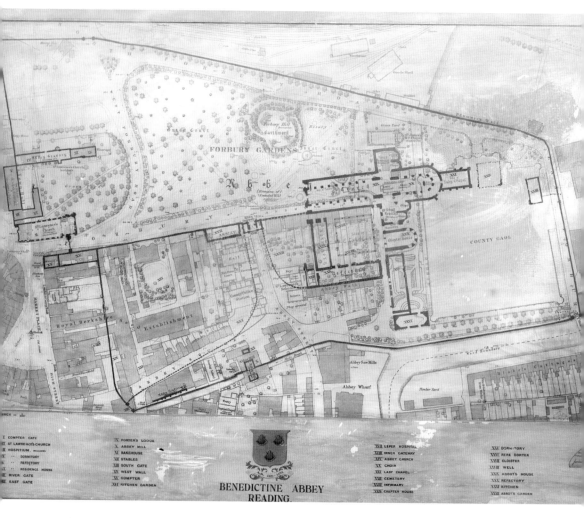

BENEDICTINE ABBEY READING.

Above: Map of Reading Showing Outline of Abbey
This photograph, taken by Henry W. Taunt, shows a map of Victorian Reading. However, superimposed upon it is an outline, prepared by Dr Stunge, of the original Reading Abbey. (Historic England Archive)

Opposite above: Abbey Gatehouse
The thirteenth-century gatehouse of the abbey was restored by Scott in 1861. It was founded in 1129 by Henry I as a Benedictine monastery. (Historic England Archive)

Opposite below: Forbury Fountain
This colourful photo, taken by M. J. Ridley in the early twentieth century, is a view of the fountain in Forbury Gardens with St James' Church in the background. (Historic England Archive)

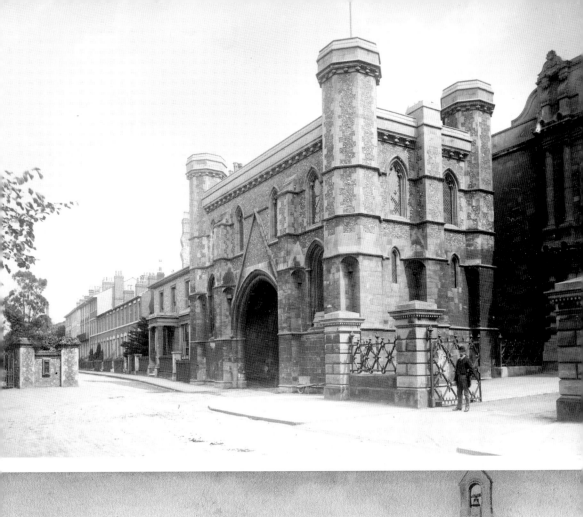

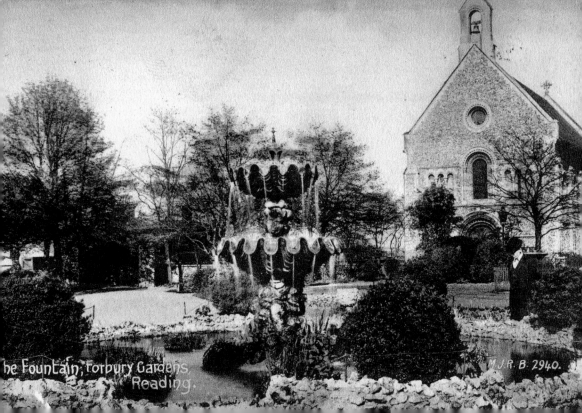

he Fountain, Forbury Gardens Reading.

M.J.R.B. 2940.

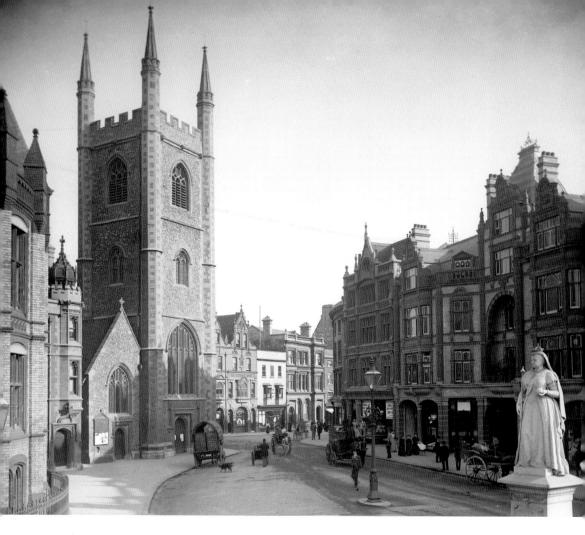

Above: St Laurence's Church
St Laurence's Church was probably built around the same time as the abbey. However, it is possible that there was an earlier church on the site. It was enlarged in 1196. In the seventeenth century the Belgrave Piazza, a 'very fair walk', was built under the south side of the church. This photograph was taken in 1890 by Henry W. Taunt. (Historic England Archive)

Opposite above: Norman Church
The Norman church at Caversham, seen in the centre of the photo, was rebuilt in 1878. This view across the River Thames was taken by Henry W. Taunt in 1883. (Historic England Archive)

Opposite below: St Peter's Church
This photo, taken in 1878 by Henry W. Taunt, shows the fourteenth-century St Peter's Church in Caversham. The tower was constructed in 1878 by Morris and Stallwood. (Historic England Archive)

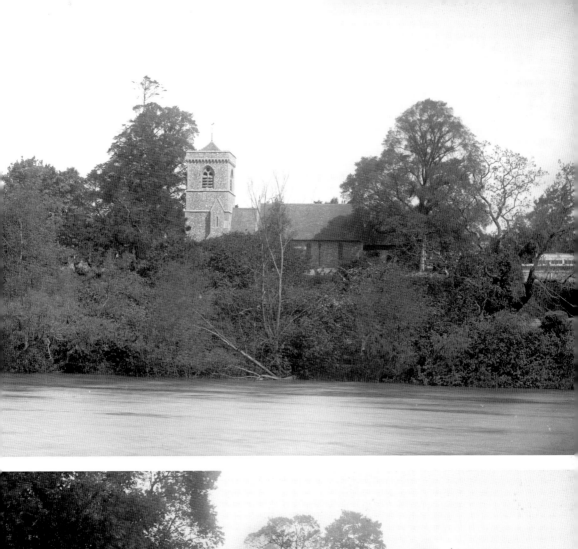

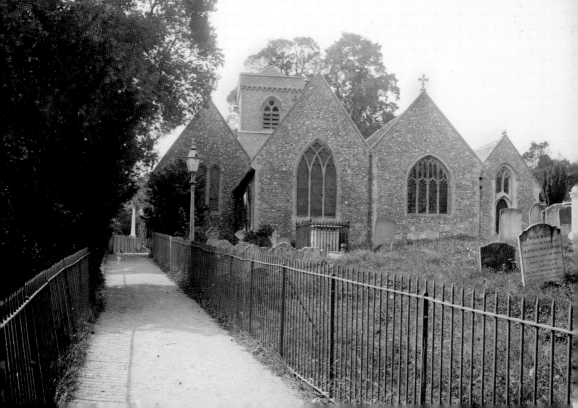

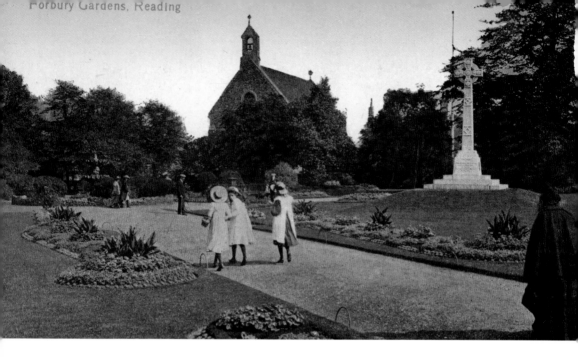

Above: Forbury Gardens
The Forbury was the forecourt of the abbey and it was here that markets and fairs were held. After the destruction of the abbey, fairs were still held up until the nineteenth century. When the council bought the area in 1860, it transformed the unkempt area into a pleasure garden. Forbury Gardens were created in 1855–61 by J. B. Clacy. (Historic England Archive)

Below: Maiward Monument
This monument in Forbury Gardens commemorates men of the 66th Berkshire Regiment who died at the Battle of Maiward in the Afghan campaign of 1879–80. Said to the largest sculpture of an erect lion in the world, it was designed by George Blackhall Simonds of the local brewing family and erected in 1886. (Historic England Archive)

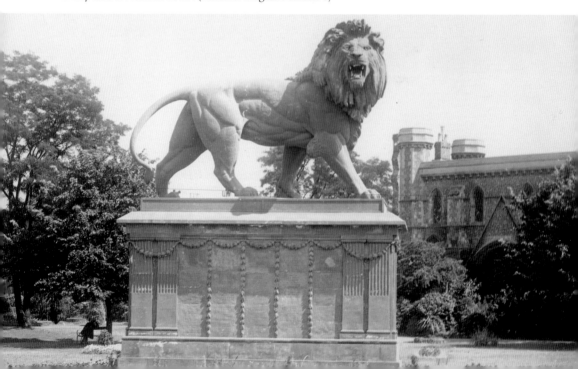

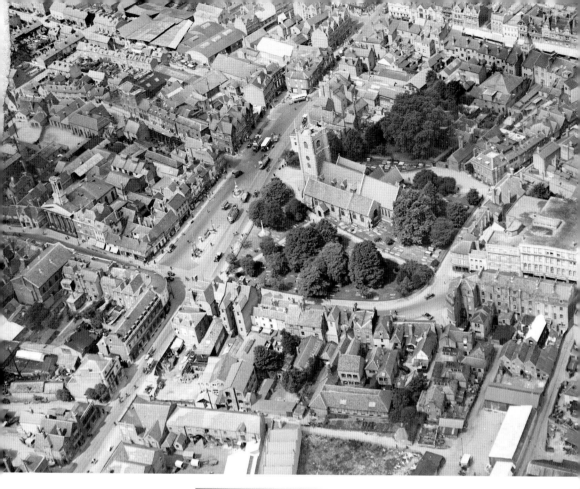

Above and right:
St Mary's Church
There had been a place
of worship on the site
of St Mary's Church,
seen on the upper right
of the aerial photo, for
over a thousand years
and it was originally a
minster church. After the
abbey was destroyed,
St Mary's was restored
using building material
from the abbey. (*Above*:
© Historic England
Archive. Aerofilms
Collection; *right*: Historic
England Archive)

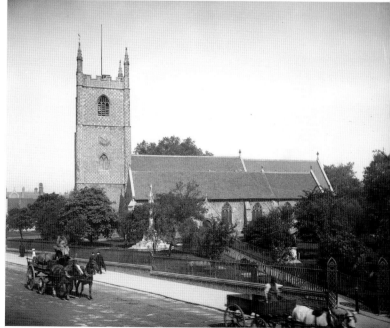

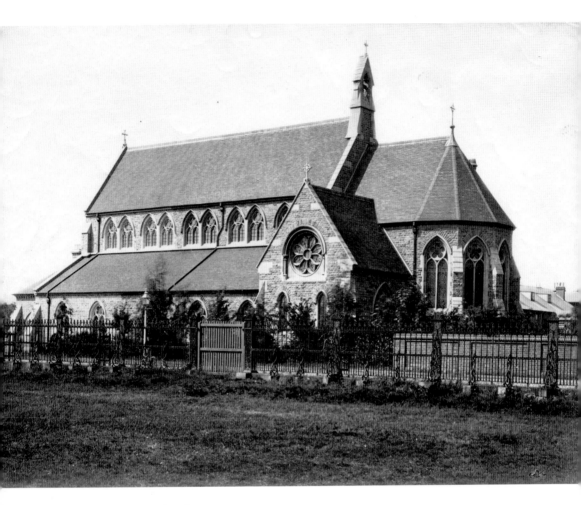

Above: All Saints' Church
The nineteenth century saw a number of new churches being built in Reading. All Saints' Church, designed by J. P. St Aubyn, was built between 1865 and 1874. Over the east end of the nave the bellcote can be seen. The big vestries were added in 1883–*c*. 1893. (Historic England Archive)

Opposite: Interior of All Saints' Church
This photo shows the interior of All Saints' Church. The nave, with its clerestory, soars upwards and three of the five windows in the chancel at the end of the nave can be seen. (Historic England Archive)

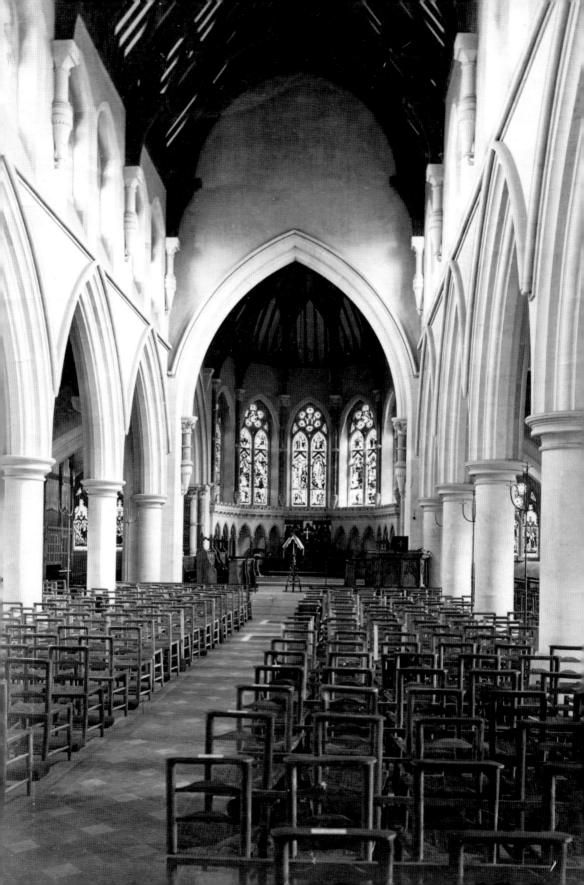

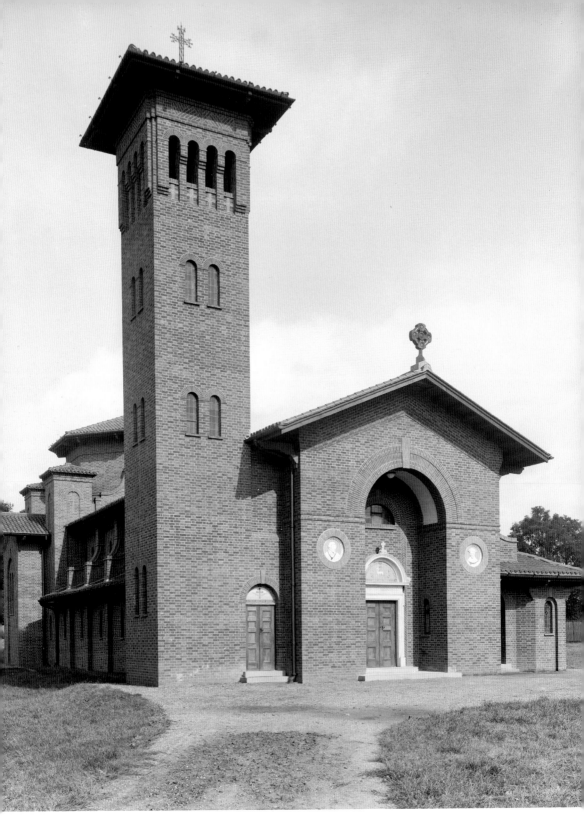

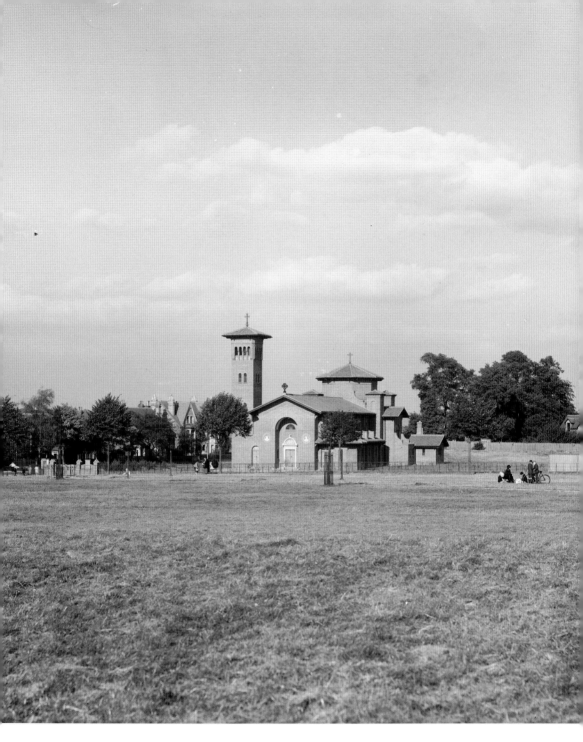

Above and opposite: The English Martyrs Catholic Church
The English Martyrs Catholic Church, Tilehurst, was built in 1925–26 and was designed by the architect W. C. Mangan. In the photo above it stands isolated at the edge of a field with a backdrop of trees. The photo opposite, a close-up, shows the straight lines of the church with the cross on top of the square tower. (Historic England Archive)

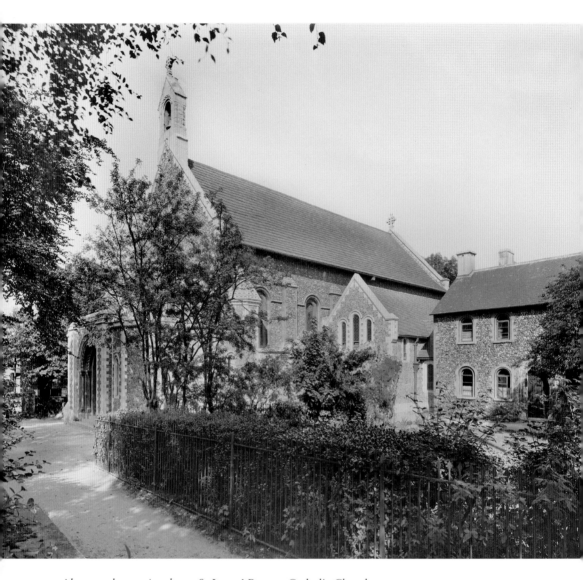

Above and opposite above: St James' Roman Catholic Church
St James' Roman Catholic Church, built in the mid-nineteenth century, was designed by Augustus Welby Northmore Pugin. In 1925 it was altered by W. C. Mangan. The two photos show the outside and the interior. Both were taken by Adolphe Augustus Boucher in 1926. (Historic England Archive)

Opposite below: Christchurch
Another nineteenth-century church, Christchurch was built by Henry Woodger and it is typical of the High Victorian ecclesiastical design. The photograph, taken by Henry W. Taunt in 1890, shows the steepled church standing on the edge of a field. Later, houses would be built near it. (Historic England Archive)

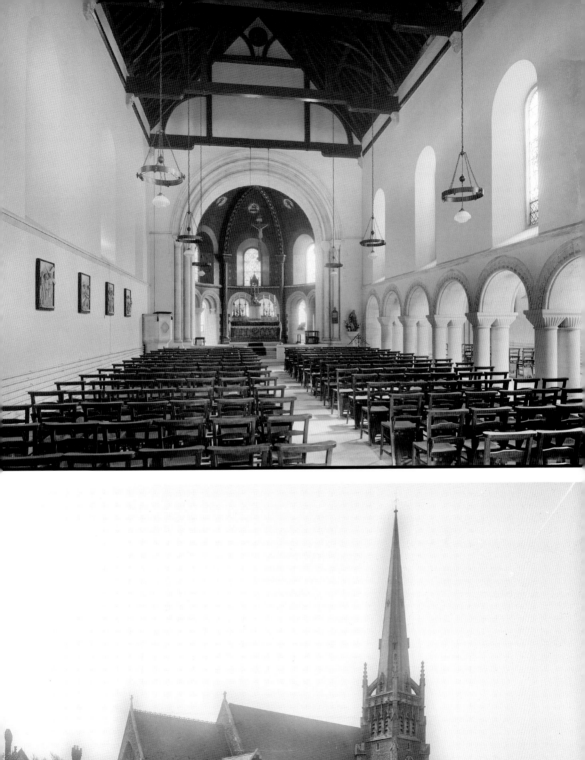

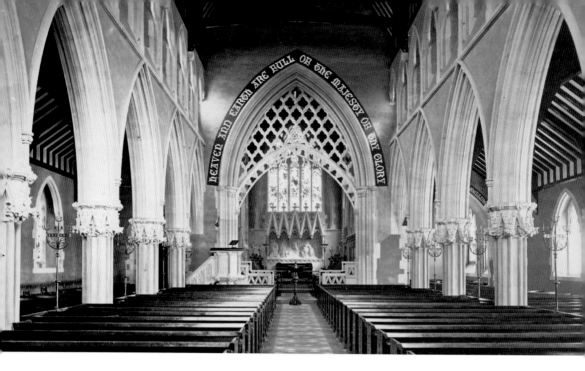

Above: Interior of Christchurch

This photograph shows the decorative interior of Christchurch. The attractive chancel arch, with its open-work tympanum, leads to the reredos and the east window. The wooden pews, separated by the aisle's decorated carpet, are flanked on either side by attractive pillars that appear to float towards the ceiling. (Historic England Archive)

Below: Reading Cemetery

When the Reading Cemetery Co. bought 10 acres of land to the right of the town, it commissioned William Brown to design a new cemetery. This was opened in 1843. 6 acres were allocated to 'church' burials and 4 acres to 'chapel'. Separate places of worship were provided for each. Dissenters' plots were near the pedimented main entrance. (Historic England Archive)

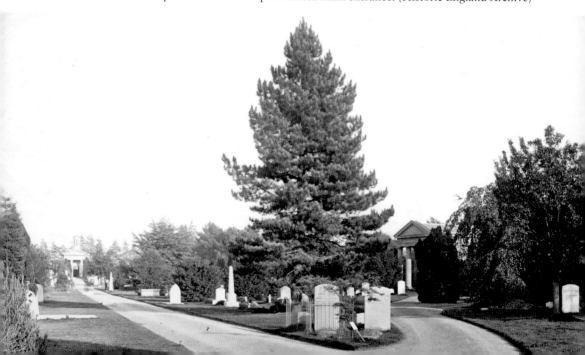

Public Buildings

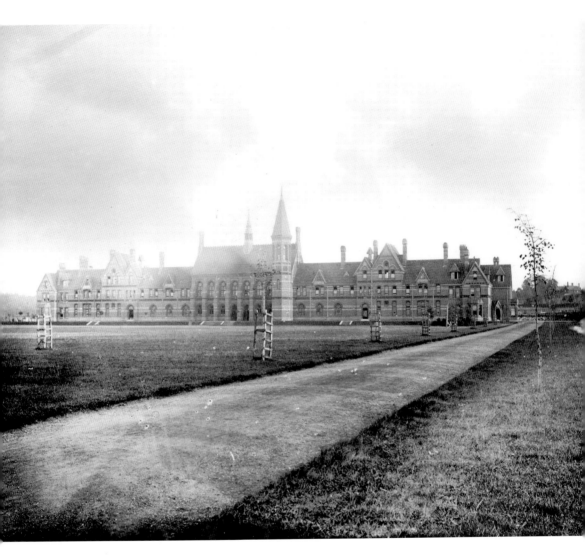

Origin of Reading School

Reading School probably originated in the abbey and a school has stood on the present site since 1486. It flourished in the eighteenth century but declined during the nineteenth and eventually closed. It reopened in 1871 and in 1916 merged with Kendrick School. Today it is a reputable grammar school and one of the oldest schools in England. (Historic England Archive)

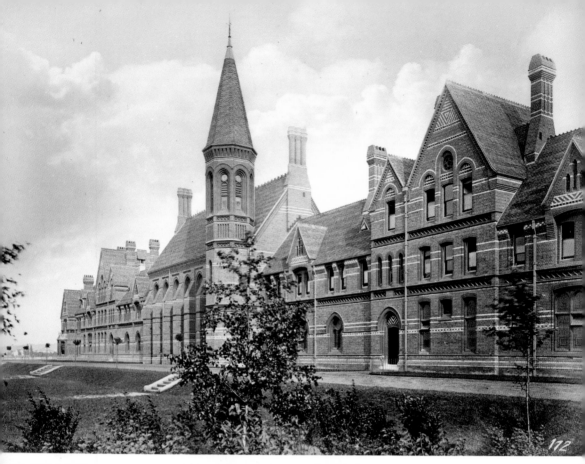

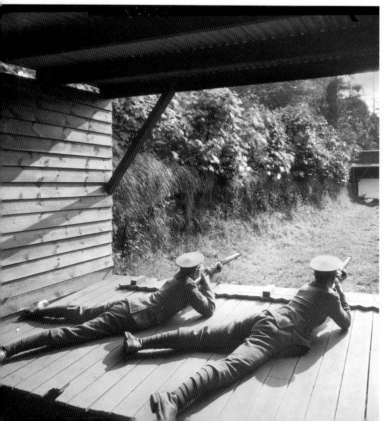

Above: Reading School
The present Reading School building was built in 1868–72 (according to Pevsner) and was designed by the architect Alfred Waterhouse. This photo, taken in 1872, shows the north elevation of Reading School. (Historic England Archive)

Left: Cadets
This photograph was taken in the early twentieth century. It shows cadets in the Officer Training Corps at Reading School training in a firing range. (Historic England Archive)

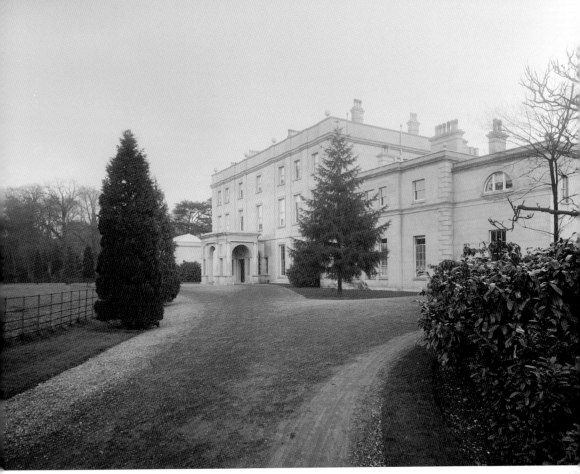

Above: Caversham Park
Dating back to Norman times, Caversham Manor had several owners over the centuries. Charles I was imprisoned there during the Civil War. In the First World War it became a soldiers' convalescent home and in 1923 the Oratory School bought it. It was requisitioned by the government in the Second World War and in 1941 the BBC and Radio Berkshire moved in to stay. (Historic England Archive)

Right: Vestibule at Caversham Park
In the nineteenth century Caversham Manor was owned by the Crayshaw family. In 1850 the house was burnt down but was rebuilt by William Crawshay II, an ironmaster nicknamed the 'Iron King'. The interior designer was C. E. Sayer. This photograph, taken by C. J. Cray in 1892, shows the vestibule in the new house. (Historic England Archive)

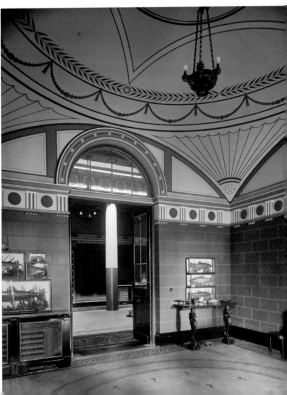

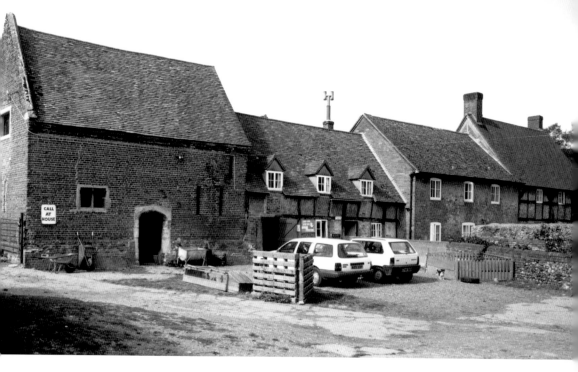

Above: Chazey Court Farm
This photo shows the Grade II*-listed Chazey Farm, which is a complicated group of buildings dating from the mid-sixteenth century to the mid-nineteenth century and incorporating some reset Norman architectural details. The building on the left is a mid-seventeenth-century stable. (© Crown copyright. Historic England Archive.)

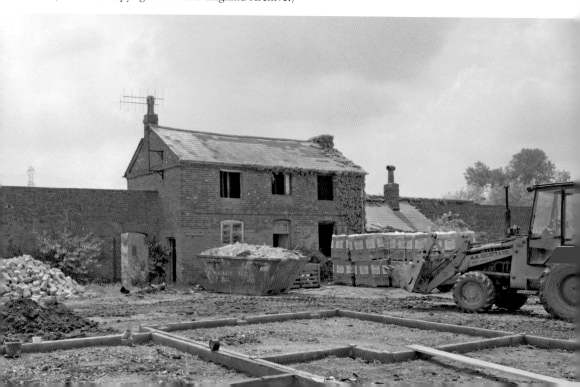

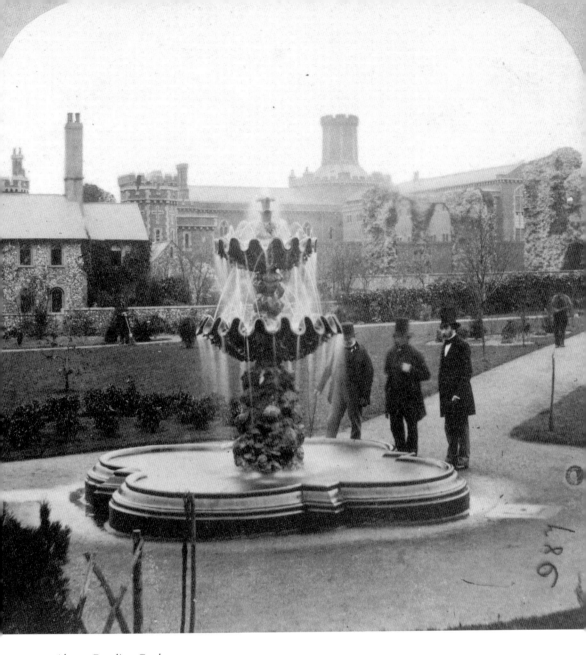

Above: Reading Gaol

From 1403 prisoners had been incarcerated in the county gaol in Castle Street. However, over the centuries conditions in the gaol deteriorated and in the eighteenth century a new prison, designed by architect Robert Bressingham, was built on the site of the present Reading Gaol. Bressingham's gaol was replaced by the current gaol, which was designed by Scott and Mottat's in 1842–44, and is shown in the background of this photograph. (Historic England Archive)

Opposite below: Coley Park Farm

Vachell House was built by Thomas Vachell in the mid-sixteenth century. The house was supplied with farm produce from Coley Park Farm. Some buildings from this period still survive and can be seen in the photograph. (© Crown copyright. Historic England Archive.)

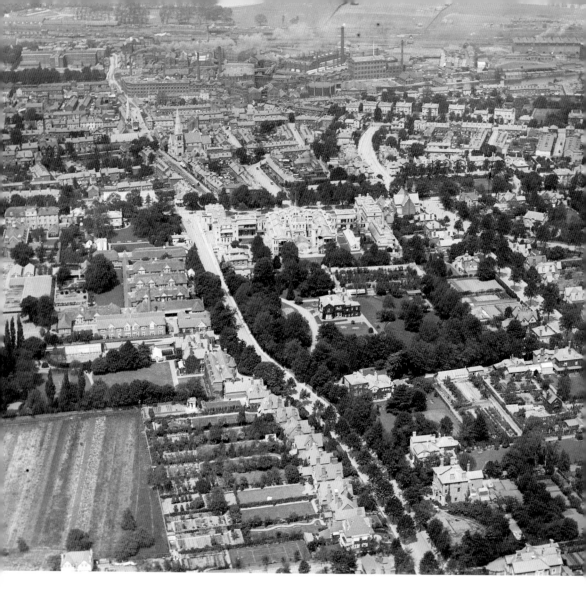

Above: Aerial Photo of Reading with Hospital

In 1802 Reading Dispensery was set up to serve the town's citizens but a new hospital was needed. Land was bought from Lord and Lady Sidmouth and fundraising started. William IV contributed, so when the hospital opened in 1839, Royal was added to its title. The aerial photo shows the town of Reading and the Royal Berkshire Hospital. (© Historic England Archive. Aerofilms Collection)

Opposite above: The Royal Berkshire Hospital

The Royal Berkshire Hospital, built in 1837–39 by Henry Briant, was made of Bath stone. In 1861 wings were added. The photo shows the exterior of the building from the road and was taken in 1865. (Historic England Archive)

Opposite below: Coroner's Court

This photo, taken in January 1981, shows the exterior of the Coroner's Court on London Street. (© Crown copyright. Historic England Archive.)

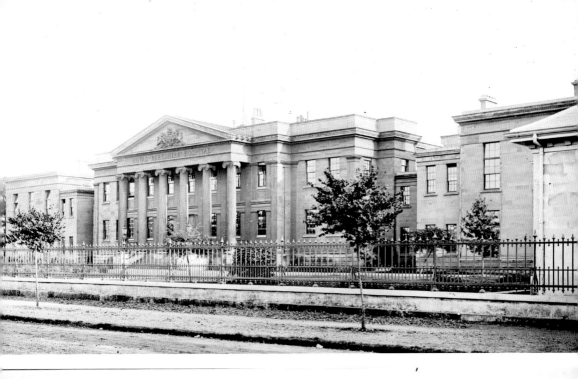

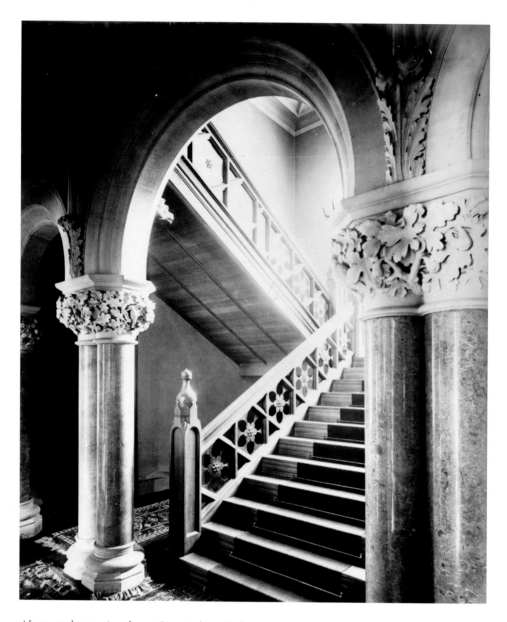

Above and opposite above: Cressingham Park
In the middle of the nineteenth century Cressingham Park was owned by Mosely Lonergan. The builder of the Victorian manor house was J. Moffat and the architect T. F. Mullett. The photo opposite shows the house in the spacious grounds. The photo above shows the detail of the staircase and pillars in the hall. (Historic England Archive)

Opposite below: White Hart Hotel
The White Hart Hotel is in a prime location on the banks of the river. On the left of the photo the nineteenth-century iron bridge can be seen. Boats, perhaps from visitors, are moored beside the hotel. The photo was taken in 1880 by Henry W. Taunt. (Historic England Archive)

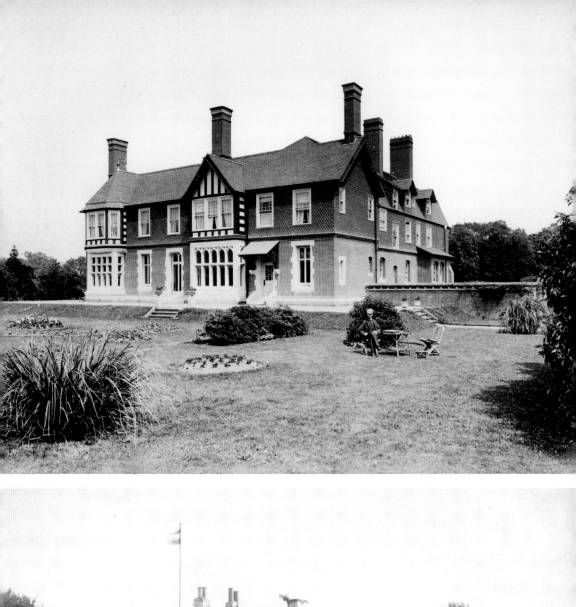

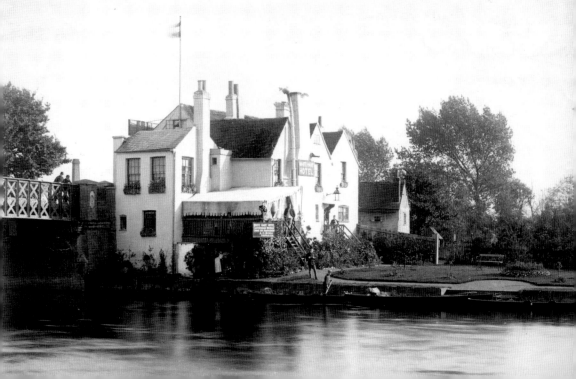

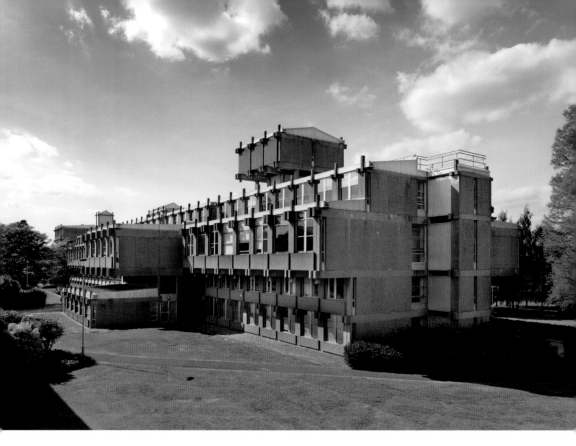

University of Reading
The University of Reading started as a college in the late nineteenth century. In 1893 the students took up residence in the hospitium next to St Luke's Church. The college became a university in 1926 and moved to the Whiteknights campus on which it still resides. The photo shows the College of Estate Management, which was designed by Howell, Killick, Partridge and Amis and has recently been listed at Grade II. It was built in 1970–73. (© Historic England Archive)

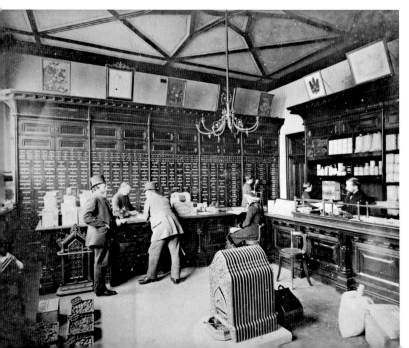

Sutton's Seed Shop
This photo shows the interior of Sutton's Seed Shop in the Market Place around 1880. Customers are inspecting the goods. It was Herbert Sutton who, in 1893, let the hospitum he owned to the college at a nominal rent. (Historic England Archive)

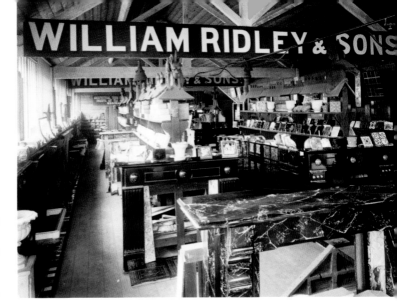

William Ridley & Sons
This photo shows the
interior of William Ridley's
showroom. It is crowded
with fireplaces and ceramic
goods. The photograph
was taken in July 1888.
(Historic England Archive)

Wellsteeds Costumiers
This spacious interior shows the ladies' wear department of Wellsteeds Costumiers in Broad
Street in 1920. Mannequins display functional day dresses and other clothing hangs on racks.
Chairs are available for weary customers. The photo was taken by Henry Bedford Lemere.
(Historic England Archive)

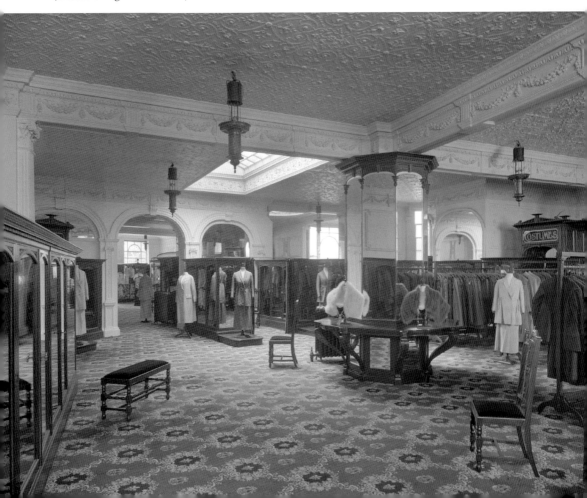

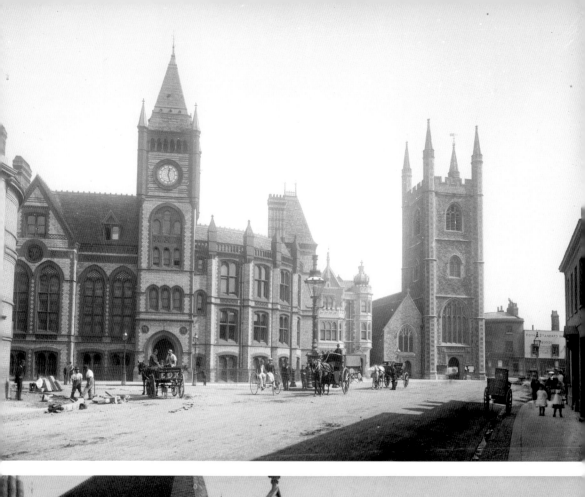

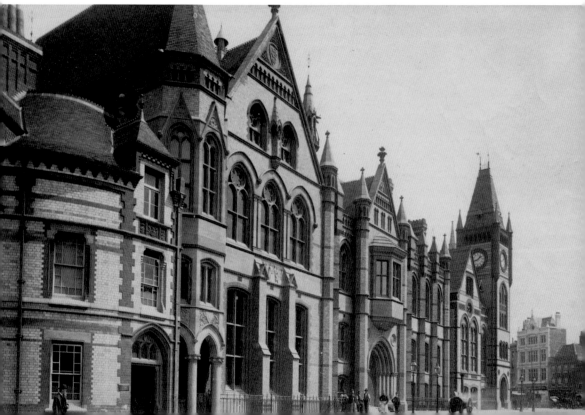

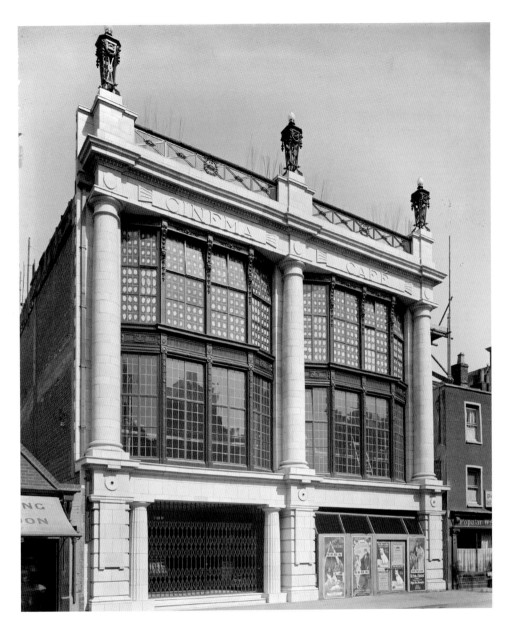

Above: Friar Street Cinema
The cinema in Friar Street opened in 1921 with the film *The Call of the Road*. It originally housed a café and a ballroom. Over the years it had several name changes, ending with ABC Reading. It closed in 1999 and the site is now occupied by the Hotel Ibis. (Historic England Archive)

Opposite: The Town Hall
The large Gothic Town Hall, with its clock tower, was built between 1872 and 1897 in front of its eighteenth-century predecessor. Alfred Waterhouse designed the principal façade. It underwent a major refurbishment in 2000. The acoustics are excellent and the Concert Hall contains the restored Father Willis organ. Concerts with varied programmes are frequently held. (Historic England Archive)

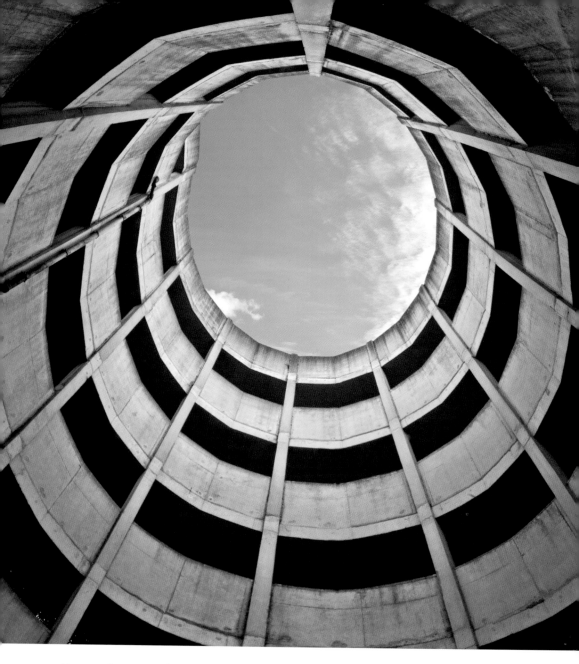

Above and opposite above: Reading Station Car Park
The railway extended to Reading in March 1840 and soon became an important railway junction. Because of the increasing number of commuting passengers who needed to park their cars, an impressive multistorey car park was later built. The photo opposite shows the enclosed spiral entrance ramp while the photo above looks up to the circular void. (© Historic England Archive)

Opposite below: Women's Ward
This photo shows the nurses and patients in the spacious and well-lit women's ward in the Royal Berkshire Hospital. The hospital opened in 1839 and was extended in the 1860s. (Historic England Archive)

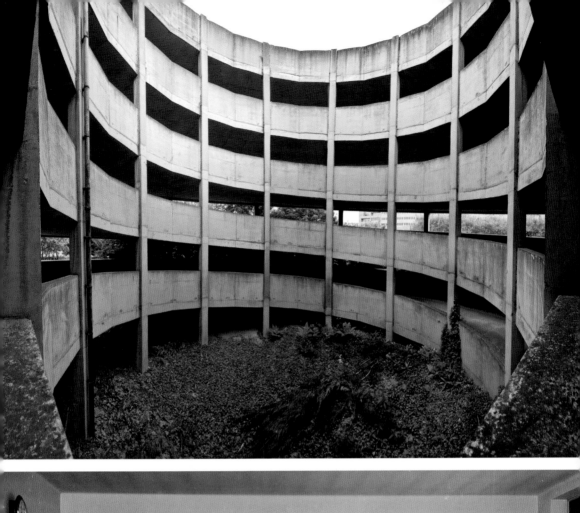

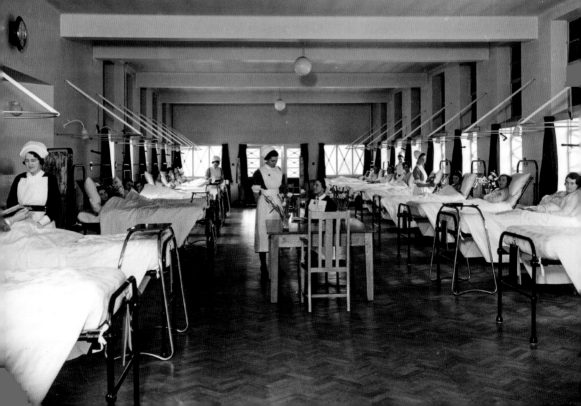

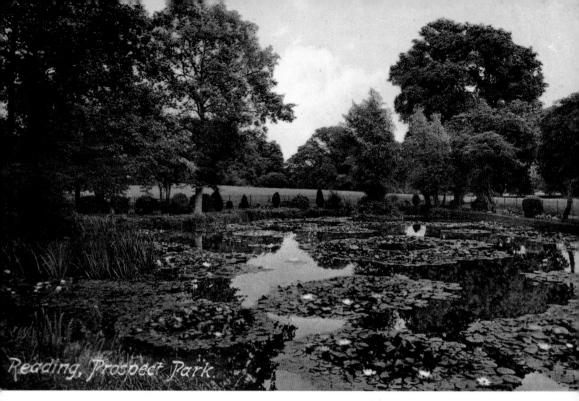

Reading, Prospect Park.

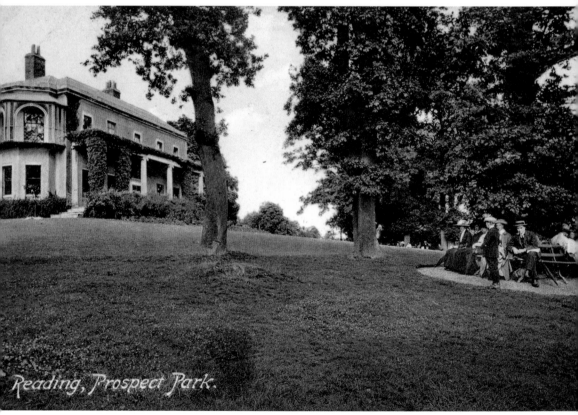

Reading, Prospect Park.

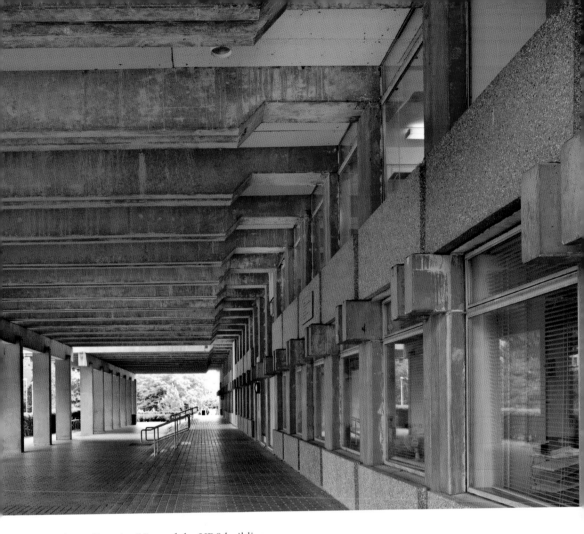

Above: Exterior View of the URS building
An exterior view of the URS building of the University of Reading situated in Whiteknights Estate. The photo was taken in June 2015 by Hames Davies. (© Historic England Archive)

Opposite above: Prospect Park
A colourful view across the lake in Prospect Park, which was incorporated by Reading Corporation in 1903. The land was once part of the Calcot Park estate. This photo was taken in the early twentieth century. (Historic England Archive)

Opposite below: Garden and House
This colourful photo, taken in the early twentieth century by M. J. Ridley, shows the decorative garden in the foreground of Prospect House. (Historic England Archive)

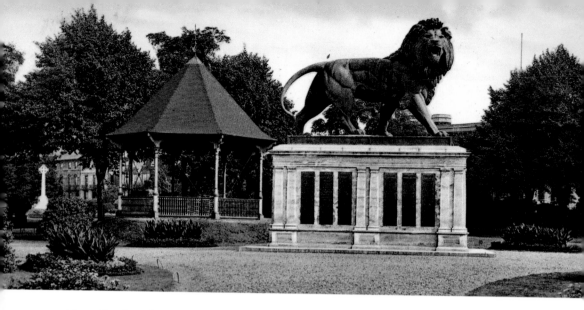

Above: Bandstand
A colourful view of the Maiward Monument in Forbury Gardens with the bandstand in the background. (Historic England Archive)

Below: Hansom Cab
This photo, taken by Henry W. Taunt in 1880, shows a Hansom cab on the corner of Blagrave Street. The large Gothic building, designed and constructed by Waterhouse between 1872 and 1875, housed the Town Hall and the Assembly Hall. Later it was an art gallery and public library. (Historic England Archive)

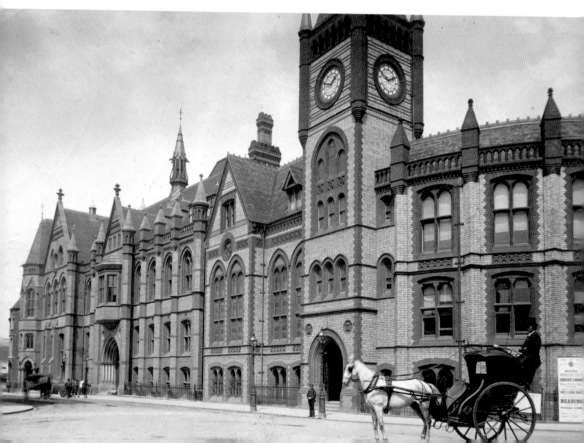

Streets

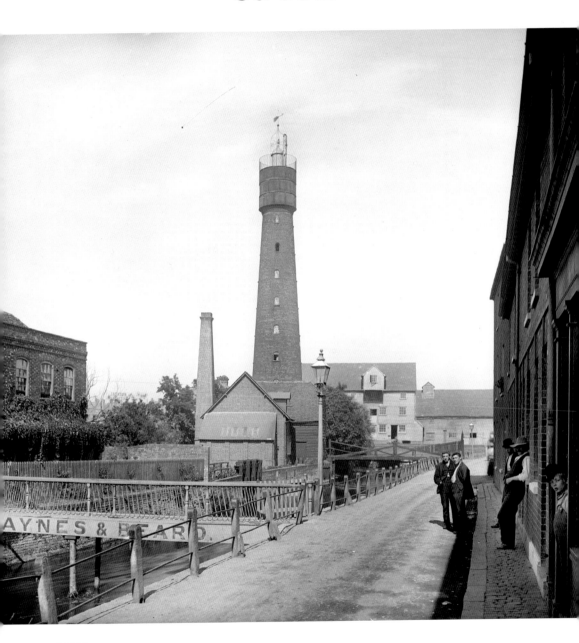

Mill Lane
This view along Mill Lane, taken in 1890, shows the water tower pumping station and mill. On the left is the Baynes and Beard building. Six mills in this area were mentioned in the Domesday Book; the watermill in the photo was the only one remaining on the site. It was demolished in 1903. (Historic England Archive)

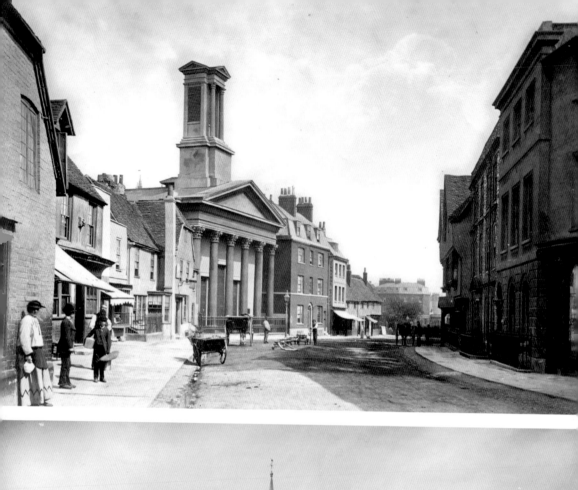
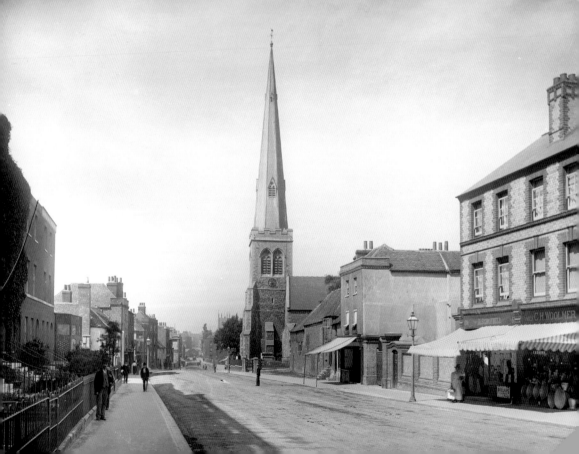

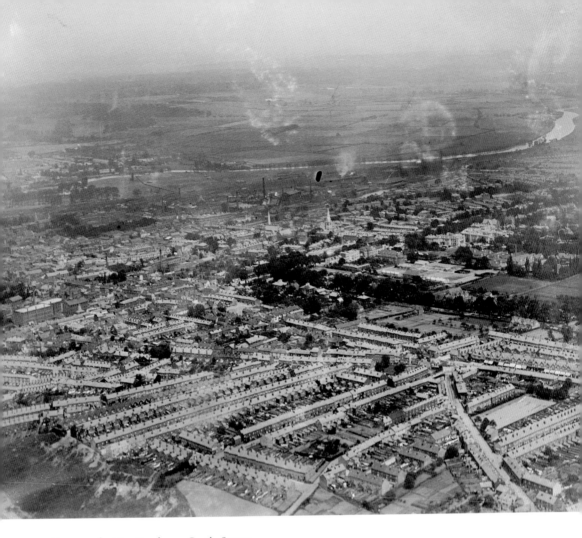

Above and opposite above: Castle Street
This aerial view of Reading with Castle Street running through the centre was taken in 1920. It shows a view from the south-west of the town. The other photo shows the Episcopalian Chapel in Castle Street in 1875. It was originally built by Billing in 1798 but was restored in 1840–42. Sadly, the impressive cupola on top of the building has now disappeared. (© Historic England Archive. Aerofilms Collection)

Opposite below: Southampton Street
This photo shows Southampton Street looking towards St Giles' Church. The lower part of the tower was built in the Perpendicular style. The oldest parts of the church date to the thirteenth century but it was rebuilt to take its current form by J. P. St Aubyn in 1871–73. The ashlar steeple was added at this time. (Historic England Archive)

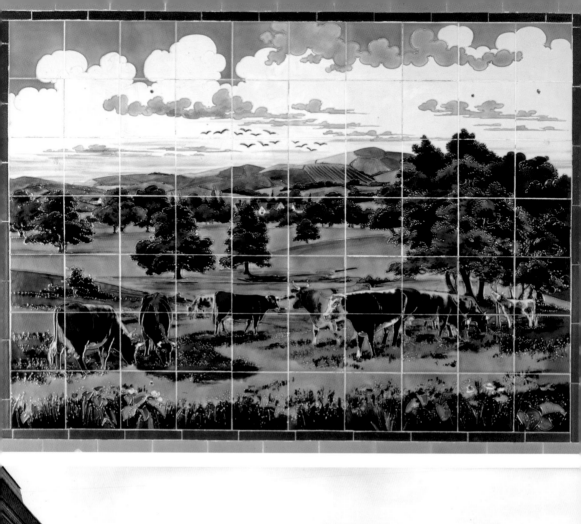
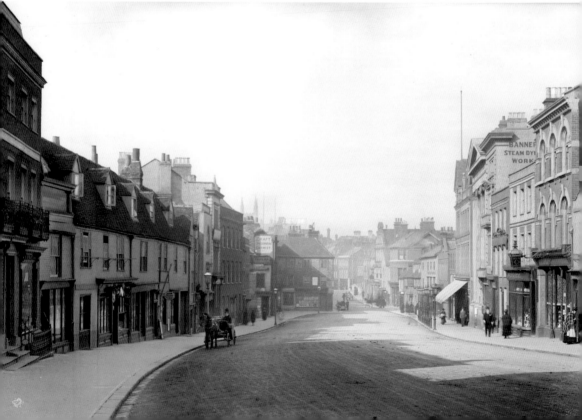

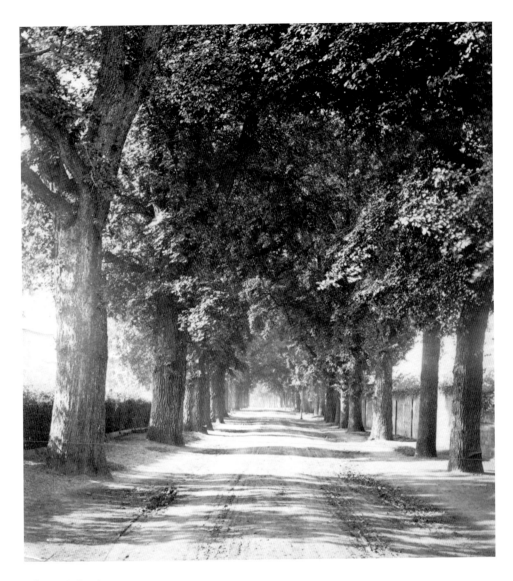

Above: Coley Avenue
This photograph of Coley Avenue, taken in 1875 by Henry W. Taunt, shows that there were still tree-lined areas in the busy industrialised town at the end of the nineteenth century. (Historic England Archive)

Opposite above: Tiled Panel
This coloured photo of a tiled panel on the wall of No. 93 London Street was taken in February 1983. It shows a pastoral scene that once occupied the now busy town of Reading. (© Crown copyright. Historic England Archive.)

Opposite below: London Street
Shopping was a popular pastime at the end of the nineteenth century and this photo, taken in 1878, shows the wide London Street lined with shops both old and new on either side. The photograph was by Henry W. Taunt. (Historic England Archive)

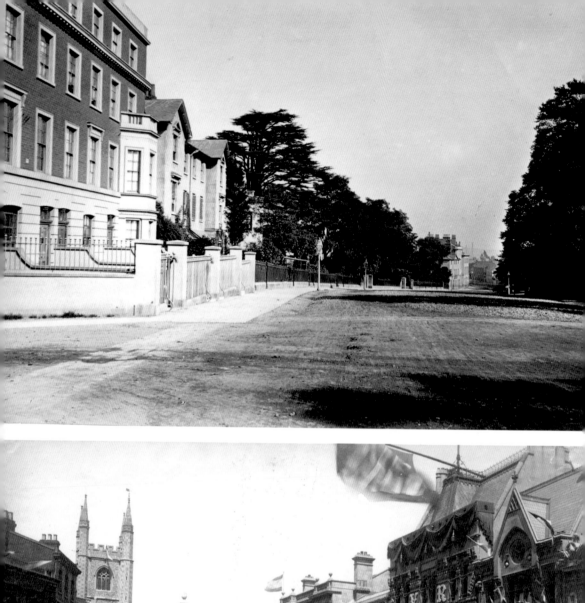
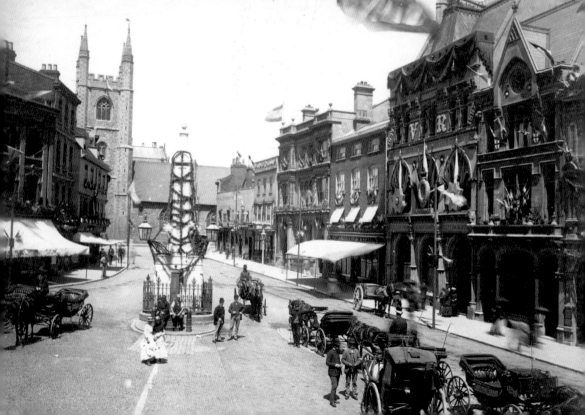

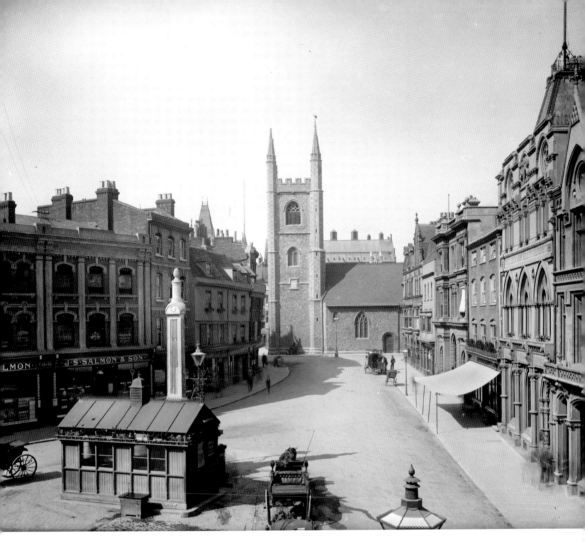

Above: Cabmen's Shelter
In the foreground on the left is a cabmen's shelter. This provided a shelter from the elements and also simple food for the men who drove the horse-drawn vehicles and later motorcars along the Market Place. This photo was taken in 1890 by Henry W. Taunt. (Historic England Archive)

Opposite above: Bath Road
Bath Road is a wide uncobbled road leading to Bath. In 1975, when the photo was taken, it was lit by gas lamps, which can be seen in the photo. (Historic England Archive)

Opposite below: Market Place
This photo, taken by Henry W. Taunt in 1887, shows the Market Place decorated with flags and wreaths to celebrate Queen Vitoria's Golden Jubilee. The tower of St Laurence's Church can be seen on the left side of the photo. (Historic England Archive)

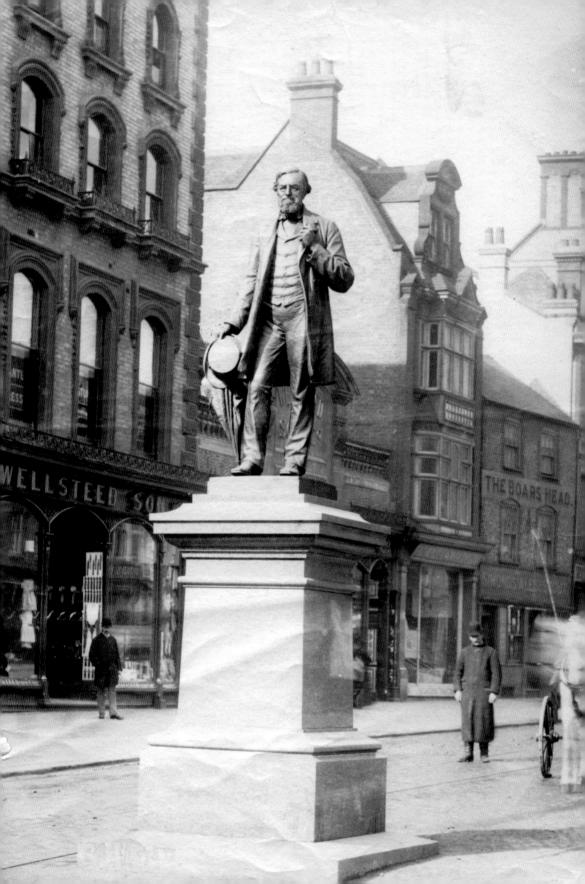

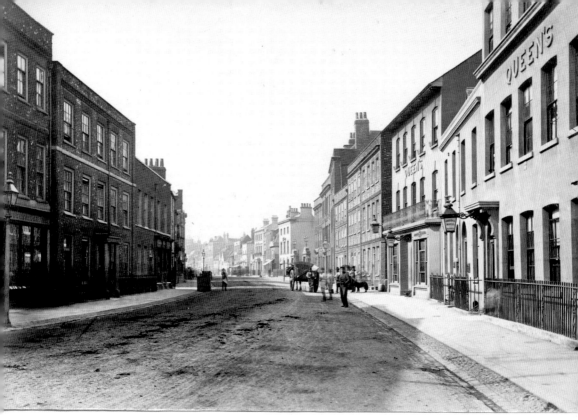

Above and right: Friar Street
The photo above shows the wide uncobbled Friar Street. The name is a reminder of the friars who came to Reading in the thirteenth century. The photo was taken by Henry W. Taunt in 1875 and shows the Queen's Hotel on the left. This later gave way to the General Post Office. A statue of Queen Victoria was erected to celebrate her jubilee. (Historic England Archive)

Opposite: George Palmer
George William Palmer was a nineteenth-century benefactor who set up a large trust fund to secure the future of The University of Reading. The town honoured him by erecting a statue of him at the end of Broad Street. (Historic England Archive)

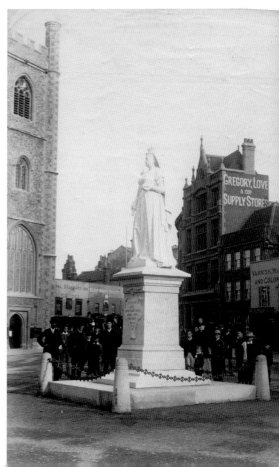

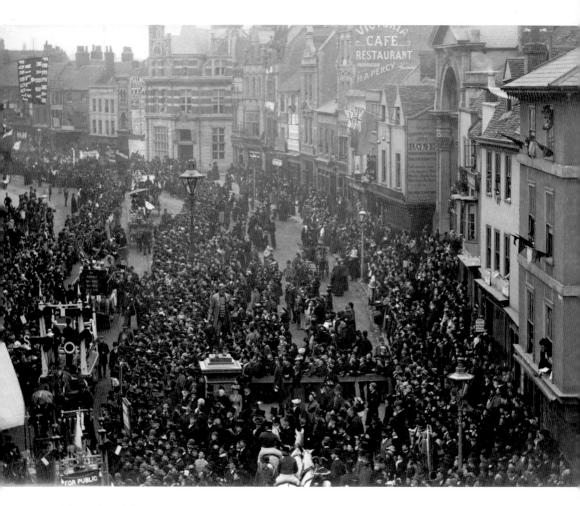

Above: Broad Street
This photo, taken by Henry W. Taunt, shows the huge crowd that had gathered in Broad Street in 1890 to watch the unveiling of the George Palmer statue. (Historic England Archive)

Opposite: Kings Road
With the coming of the railway, horse-drawn bus services were introduced to ferry passengers from shops, inns and hotels to the station. These photos show horse-drawn vehicles outside a parade of shops in Kings Road on the wide cobbled street. (Historic England Archive)

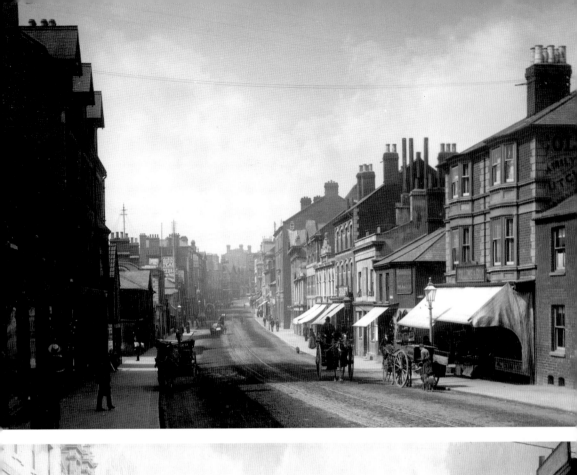
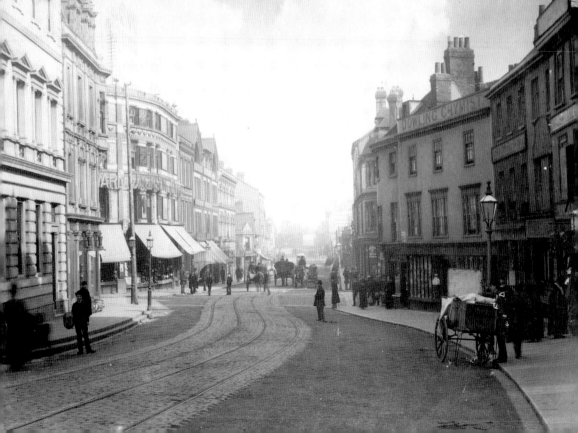

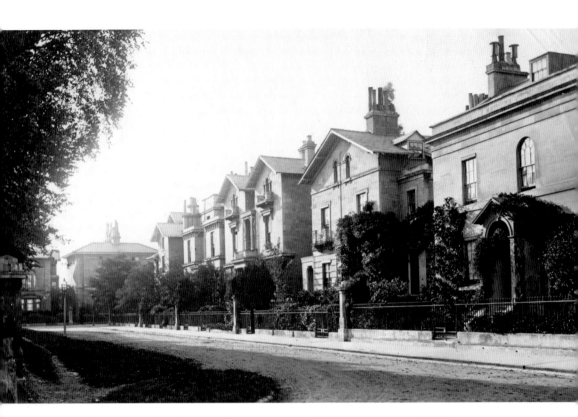

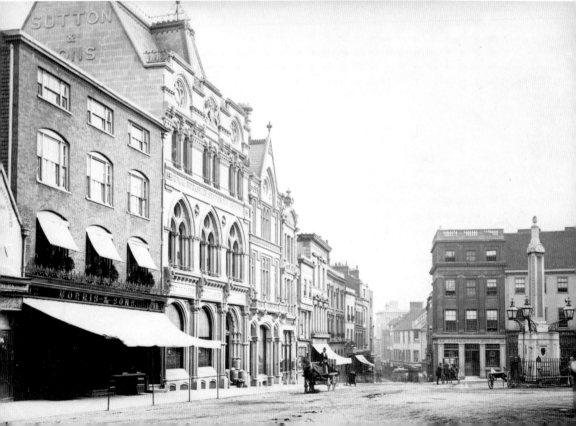

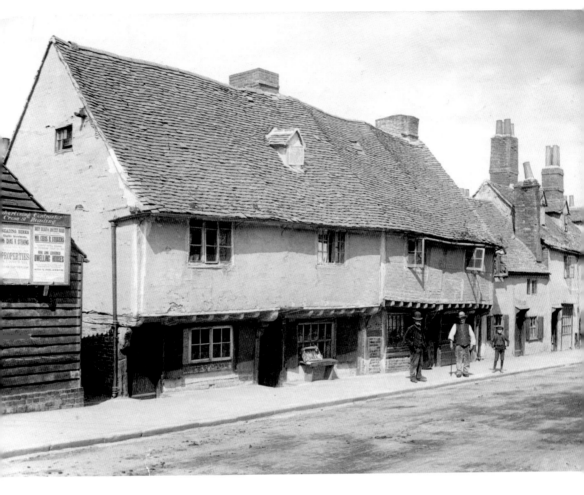

Above: Silver Street
This view of Silver Street, taken in 1890 by Henry W. Taunt, shows a terrace of old buildings on one side. These houses date from the fifteenth century but have now been demolished. (Historic England Archive)

Opposite above: Eldon Square
The north side of Eldon Square is lined with a row of attractive houses dating from the early nineteenth century. The photo was taken in 1875 by Henry W. Taunt. (Historic England Archive)

Opposite below: Simeon Monument
Edward Simeon was a nineteenth-century local benefactor who gave money for a school to be founded in Southampton Street. The monument, which can be seen on the right of the photo, was designed by John Soane and erected in the Market Place in 1804. The photo was taken by Henry W. Taunt in 1875. (Historic England Archive)

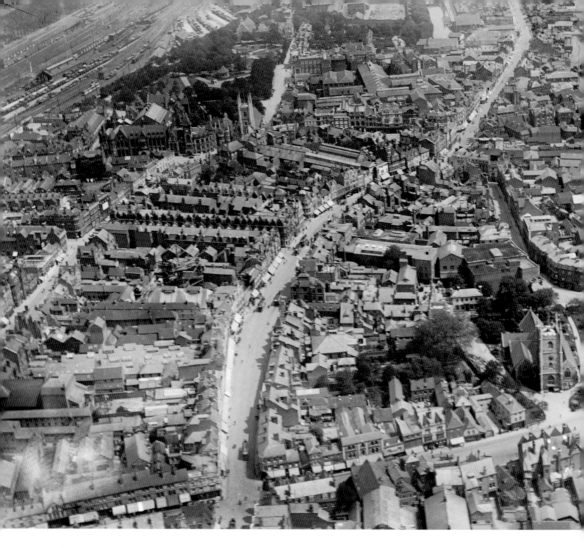

Above: Broad Street
This aerial photo of Reading, taken in 1920, shows Broad Street running through the centre of the town. Today Broad Street is pedestrianised and is one of the main shopping areas in Reading, with The Oracle at its east end and Broad Street Mall at it west end. (© Historic England Archive. Aerofilms Collection)

Opposite above: Butcher's Shop
This photo, taken between 1855 and 1910, shows a butcher's shop in castle Street. In the foreground a group of women gossip. Behind them, joints of meat hang in front of the shop. (Historic England Archive)

Opposite below: Sutton Seeds Building
This image shows the Sutton Seeds building. Henry W. Taunt took the photo in 1890. (Historic England Archive)

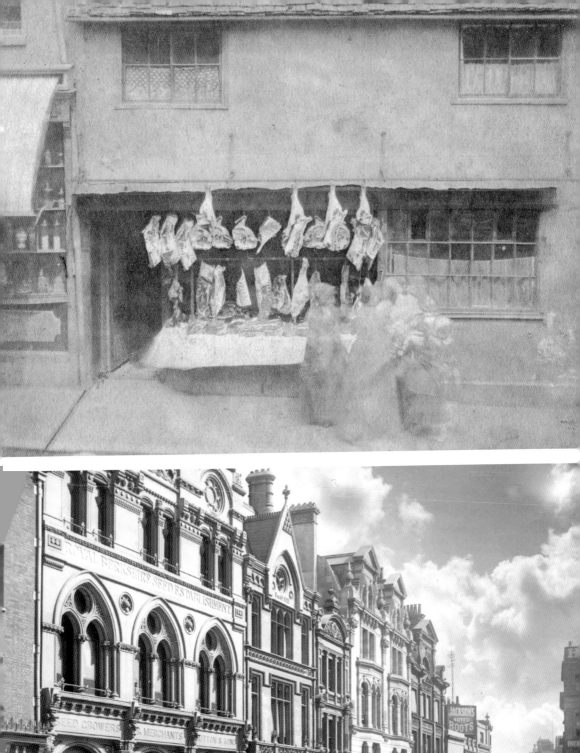
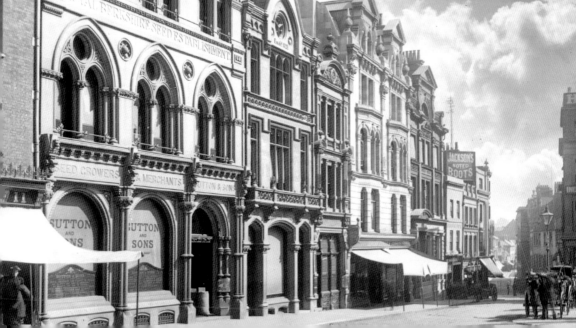

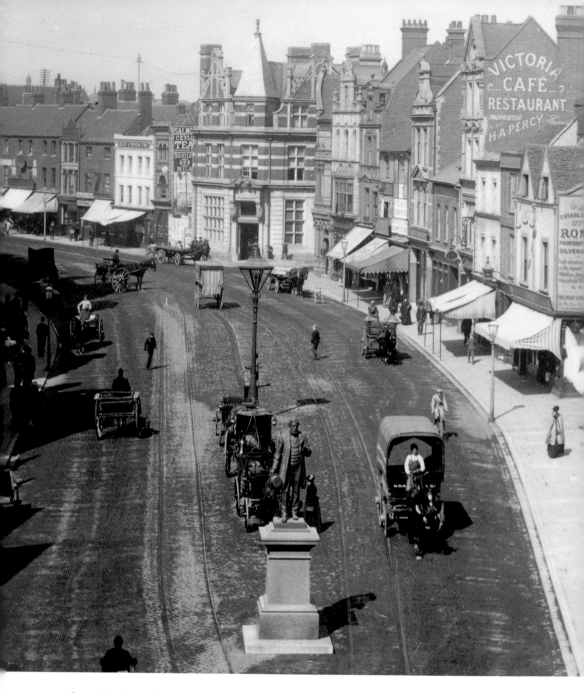

Above: Birds-eye View
This birds-eye view of Broad Street shows horse-drawn carriages passing by George Palmer's statue erected in 1890, when this photo was taken. (Historic England Archive)

Opposite above: Horse and Cart
A horse and cart trundles down Broad Street beside a line of shops with unfurled awnings. Another one is parked outside the ornate entrance of the bank on the right of the photo, taken by Henry W. Taunt in 1890. (Historic England Archive)

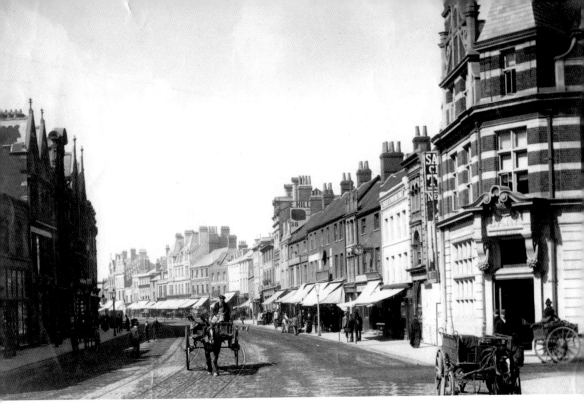

Below: St Mary Butts

Henry W. Taunt took this photo in St Mary Butts in 1887. It shows the Victorian fountain decorated with flags and banners. Local people stand around it gossiping. (Historic England Archive)

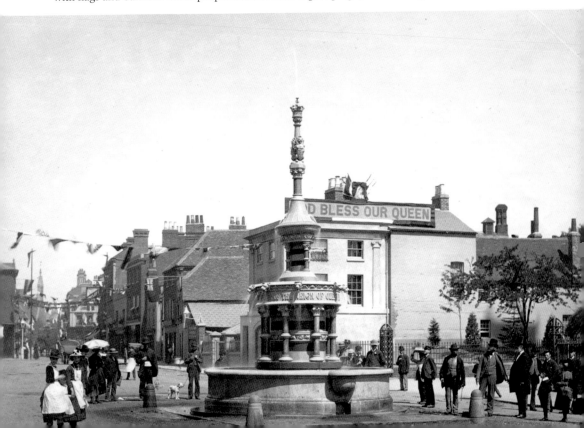

Industry

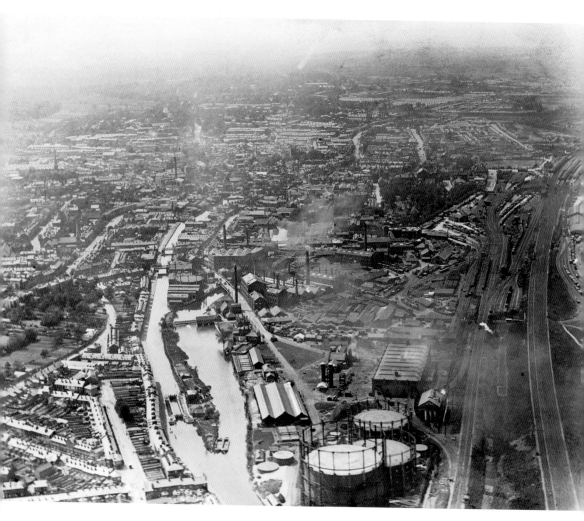

Above: Gasworks
In 1817 the public library, a billiard room and a newsroom were lit by gas for the first time. By 1821 the main streets of Reading were lit by gaslight. Gaslight remained in many of the streets until after the Second World War. This aerial photo, taken in 1920, shows the Reading Gasworks and the Avon Canal. (© Historic England Archive. Aerofilms Collection)

Opposite above: Simonds' Brewery
William Blackall Simonds opened his brewery in 1785 in Seven Bridges Street – now Bridge Street. In spite of competition, the brewery flourished and by 1839 it was the largest brewer in Reading. He introduced pale ale and used new techniques to improve the quality of the drink. This aerial photo shows the H. G. Simonds Seven Bridges Brewery and its surroundings. (© Historic England Archive. Aerofilms Collection)

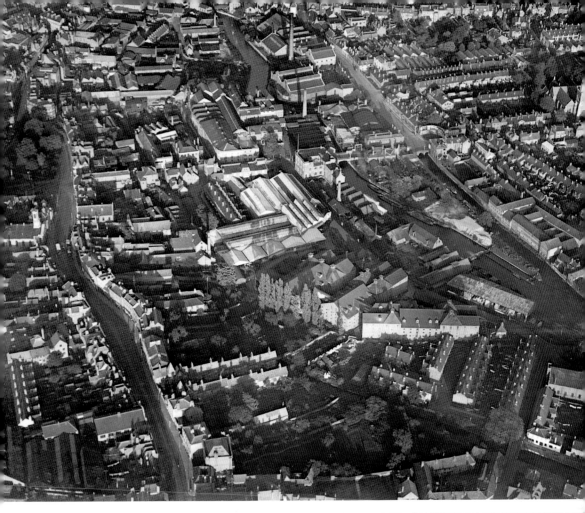

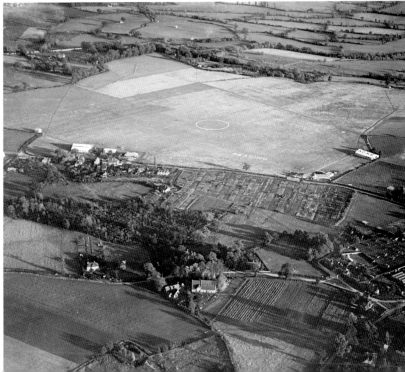

Woodley Aerodrome
In 1929 Charles Powis, a manufacturer, opened Woodley Aerodrome. By 1934 it had grown and had a thriving flying club. Crowds gathered for air displays. The designer F. G. Miles headed the aircraft manufacturing. This aerial photo, taken in 1931, shows the large space that was Woodley Aerodrome. (© Historic England Archive. Aerofilms Collection)

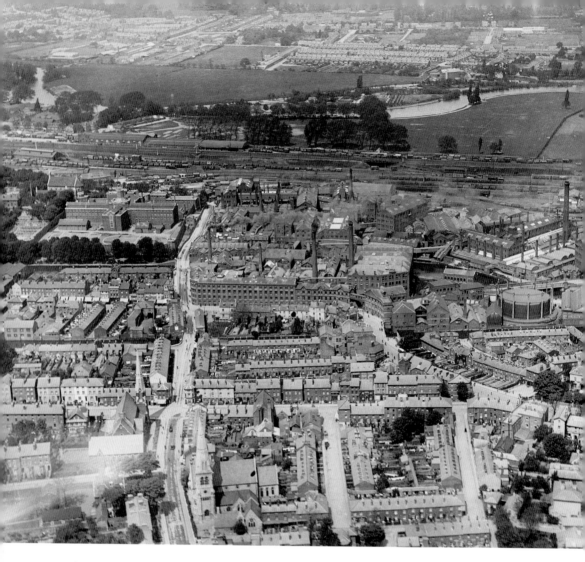

Above: Huntley and Palmers

Thomas Huntley and George Palmer were both Quakers. Thomas' father, Joseph, had opened a biscuit shop on London Street in 1822. In 1941 Thomas and George Palmer formed a partnership and in 1846 they opened a biscuit factory near the canal and the railway. This aerial photo, taken in 1920, shows the Huntley and Palmers Biscuit factory, the railway and Reading Prison. (© Historic England Archive. Aerofilms Collection)

Opposite: William Ridley & Sons

William Ridley & Sons were 'timber, slate, tile, cement and chimney piece merchants'. Their premises in Abbey Wharf has since been demolished. This photo, taken in 1888, shows their offices, which were designed by the architect W. Ravenscroft. (Historic England Archive)

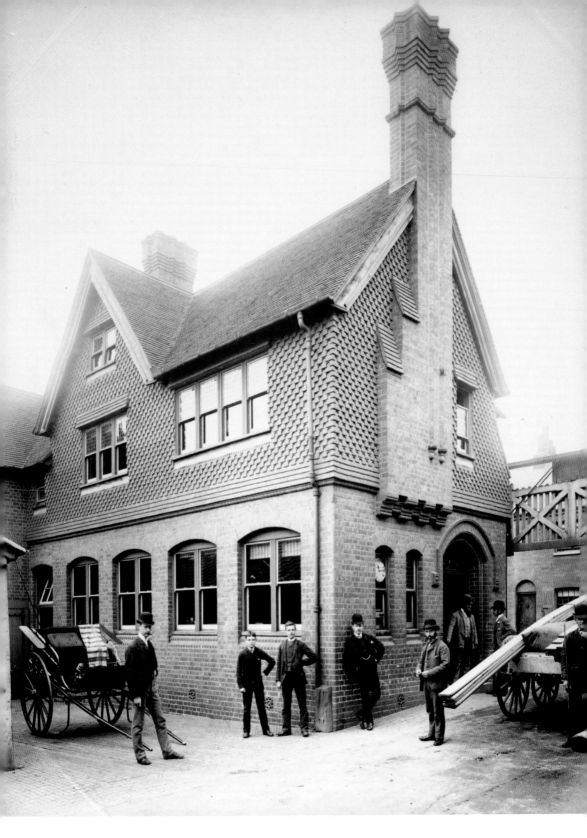

Bridges and Rivers

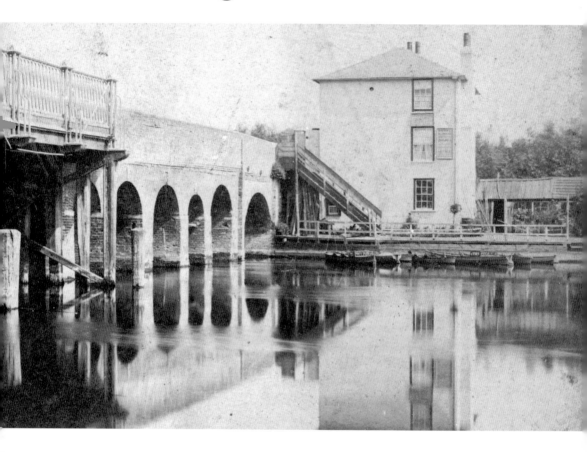

Above: Caversham Bridge
The first bridge across the Thames at Caversham was built in the thirteenth century. It had been rebuilt and altered many times but in the 1868 was completely replaced by an iron bridge. This photograph shows the southern end of the old bridge and the iron bridge under construction next to it. The three-storey Ferryman's Cottage had to be move 25 feet to the east to allow the new bridge to be constructed. The ferryman's family remained in situ throughout. (Historic England Archive)

Opposite above: Caversham Bridge
This photo shows the completed iron bridge and the Ferryman's Cottage once it had been moved. The remains of the old bridge are visible behind the iron bridge. The ferry continued to operate even after the bridge had been opened and can be seen in the foreground. This bridge was replaced by the current concrete and granite structure in 1923. (Historic England Archive)

Opposite below: High Bridge
This photo of High Bridge in Duke Street was taken in 1949 By Eric de Mare. The bridge was originally designed in 1788 by Robert Brettingham and is Grade II listed. (Historic England Archive)

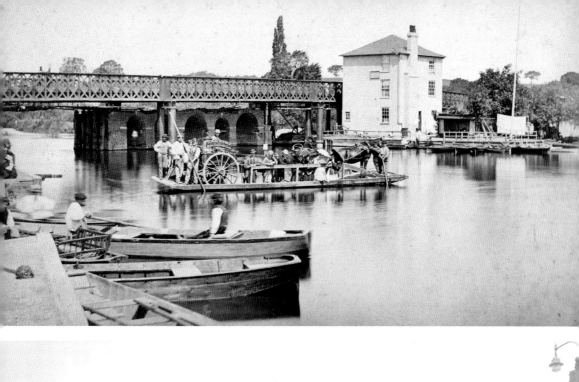
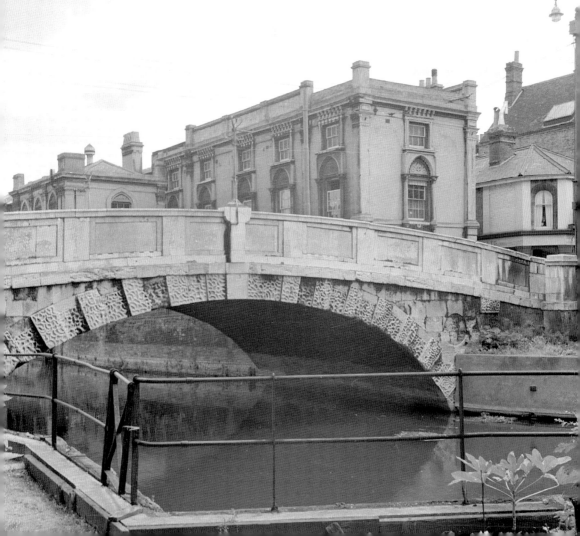

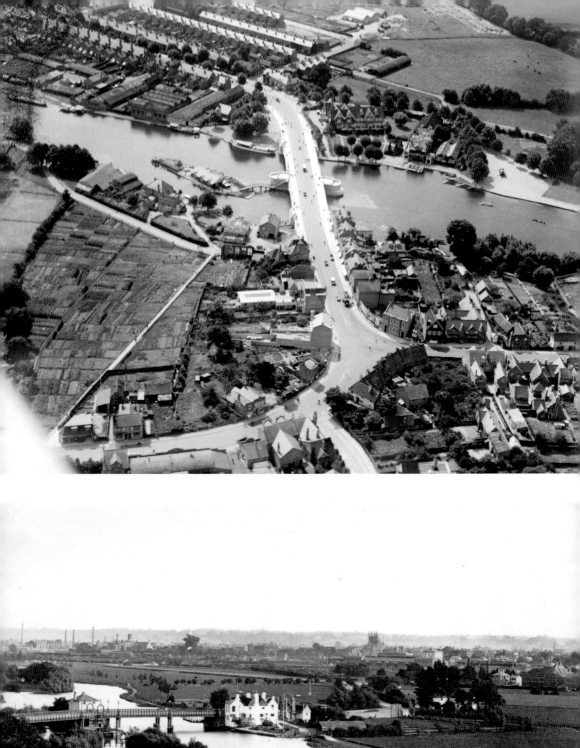
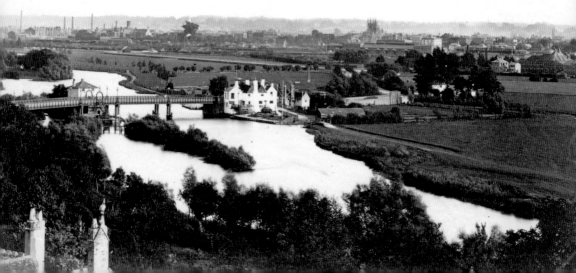

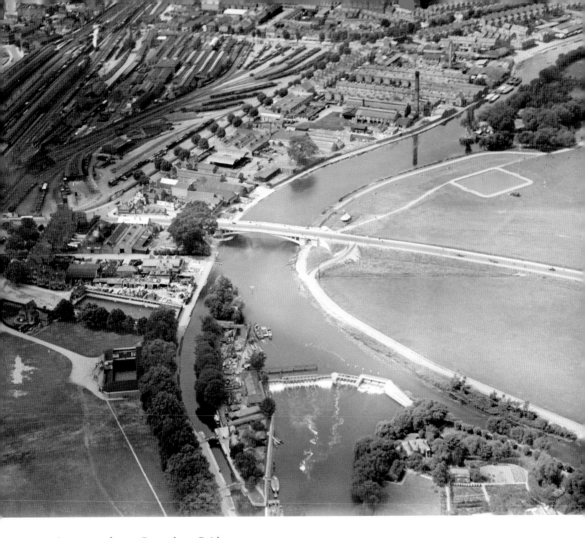

Opposite above: Caversham Bridge
Caversham was incorporated into Reading in 1911. The ancient Caversham Bridge had for centuries been a source of dispute between the two towns. Caversham built its half in stone while Reading preferred timber and iron. This photo shows the new bridge built in 1923. (© Historic England Archive. Aerofilms Collection)

Opposite below: Caversham Bridge
By the mid-nineteenth century the bridge had deteriorated, but it was not until 1868 that a new iron bridge was constructed over the River Thames. This photo was taken in 1875 by Henry W. Taunt. (Historic England Archive)

Above: Reading Bridge
This aerial photo, taken in 1928, shows Reading Bridge and its surroundings. The bridge was built in 1923 when Caversham was absorbed by Reading. The only crossing to Caversham before this was Caversham Bridge further upstream. (© Historic England Archive. Aerofilms Collection)

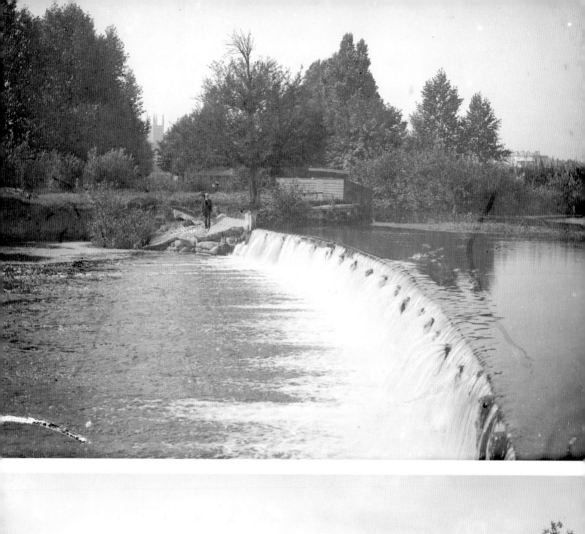
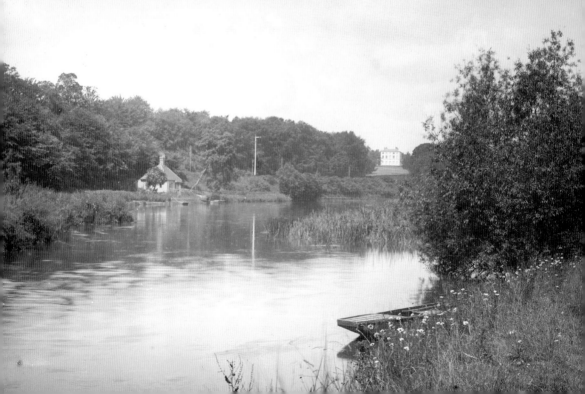

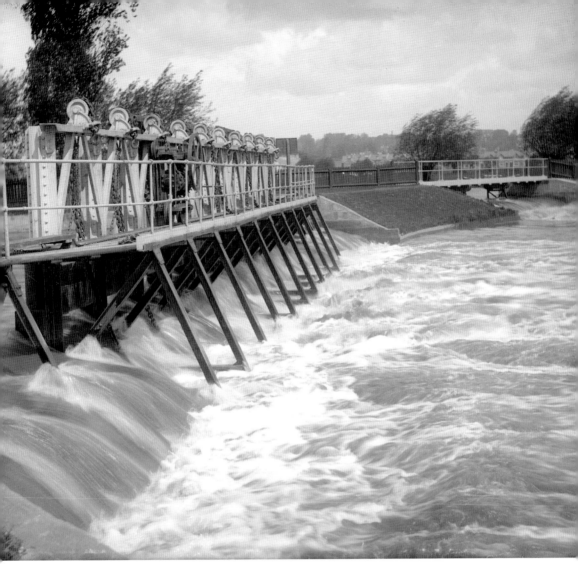

Opposite above: Weir on the River Thames
Henry W. Taunt took this early photo of the weir on the River Thames before the later wooden construction was erected. On the far riverbank the tower of St Mary's Church can be seen through the trees. (Historic England Archive)

Opposite below: Roebuck Ferry
Henry W. Taunt took this photo in 1889 looking across to the Roebuck Ferry at Tilehurst. (Historic England Archive)

Above: Caversham New Weir
Henry W. Taunt's photo of 1883 shows the new weir that was built across the River Thames at Caversham. It has a winch mechanism to control the flow of water. (Historic England Archive)

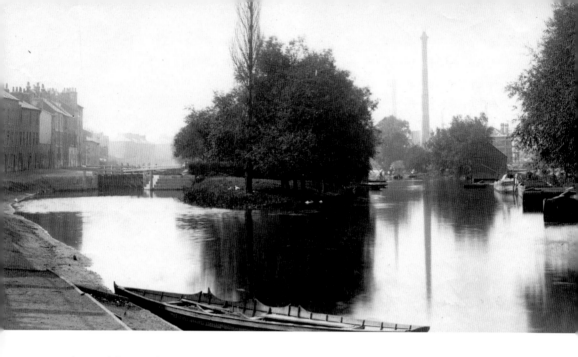

Above: Blake's Lock

Henry W. Taunt took this photo in 1880. It shows the lock on the River Thames with tall factory chimneys in the background. There was originally a flash lock here, but this was converted to a pound lock in 1802 to improve navigation. (Historic England Archive)

Below: Caversham Lock

This photo of Caversham Lock and Lock House was taken by Henry W. Taunt on a summer's day in 1890. (Historic England Archive)

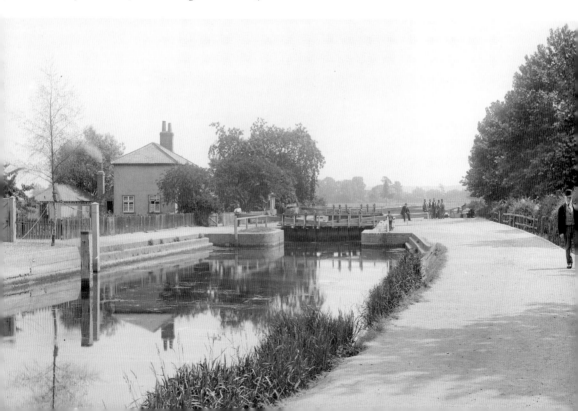

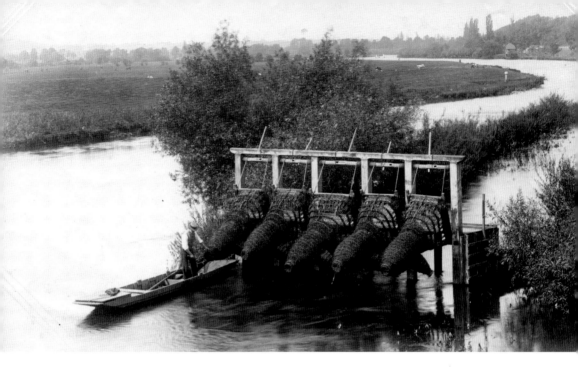

Above: Eel Bucks
Henry W. Taunt took this photo in 1880. It shows eel bucks on the River Thames at Caversham. They have been raised out of the water so that the boatman can retrieve the catches. (Historic England Archive)

Below: Replacement Bridge
This photo, taken by Henry W. Taunt in 1870, shows the whole of the impressive iron bridge across the River Thames at Caversham, which was rebuilt in 1869 to replace the earlier crumbling stone and brick structure. (Historic England Archive)

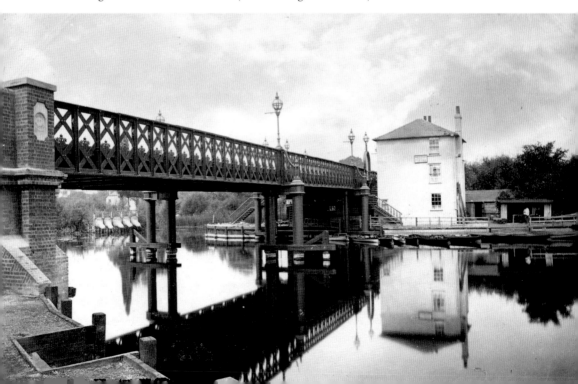

Above: The River Thames
This photo was taken in 1883 by Henry W. Taunt. It shows the wide expanse of the River Thames at Caversham. In the centre the new iron bridge can be seen with town buildings in the background. Visible on the far bank is the tower of St Peter's Church. (Historic England Archive)

Below: Clappers Footpath
This delightful colour waterscape was taken in the early twentieth century. It shows a young girl in the foreground standing on Clappers Footpath. She leans over the rail to gaze at the boats on the River Thames. Tall trees fill the background. (Historic England Archive)

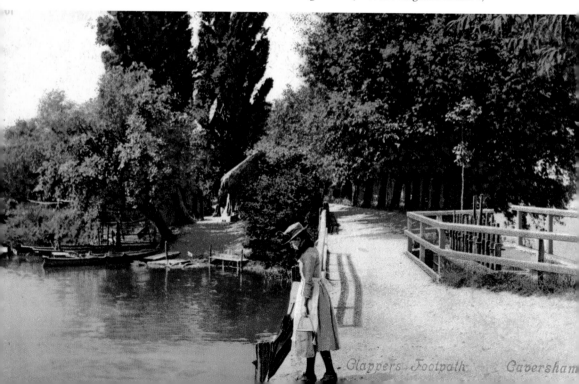

Clappers Footpath Caversham

A Reading Miscellany

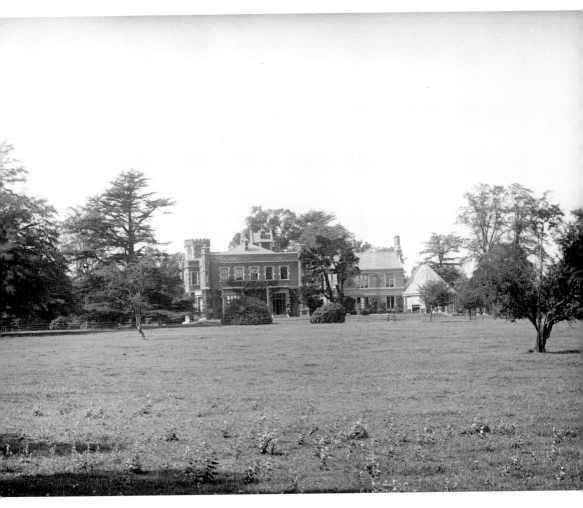

Whiteknights Estate
The vast Whiteknights Estate, on which the University of Reading now stands, goes back to medieval times. It had many owners over the centuries. At the end of the eighteenth century it passed to the Duke of Marlborough, who built a house that was demolished in 1840. (Historic England Archive)

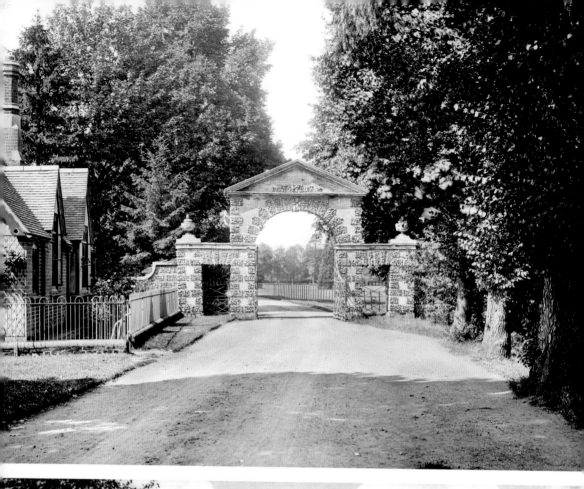

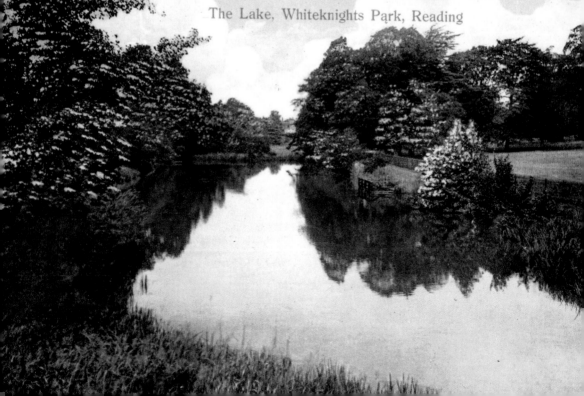

The Lake, Whiteknights Park, Reading

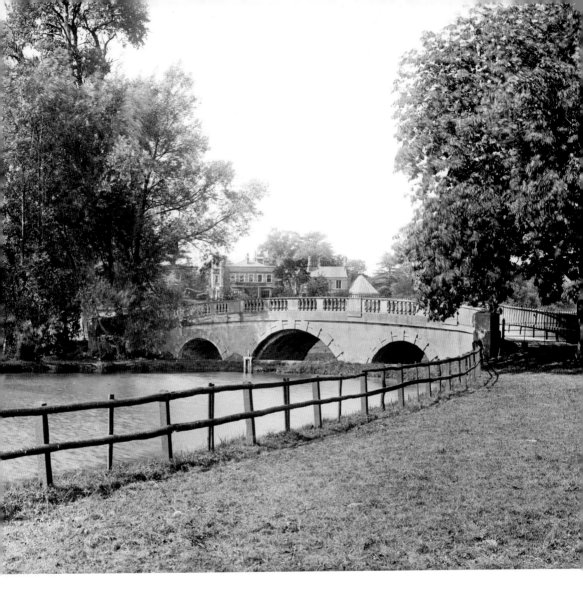

Opposite above: Whiteknights Park
The Whiteknights Lodge is on the left of this photo, taken in 1890 by Henry W. Taunt. The classical entrance archway to Whiteknights Park is flanked on both sides by trees that tower over it. (Historic England Archive)

Opposite below: Whiteknights Lake
A colourful image of the lake in Whiteknights Park. (Historic England Archive)

Above: Ornamental Bridge
This photo, taken by Henry W. Taunt in 1890, shows the ornamental bridge over the lake in Whiteknights Park. The house can be seen nestling between the trees in the background. (Historic England Archive)

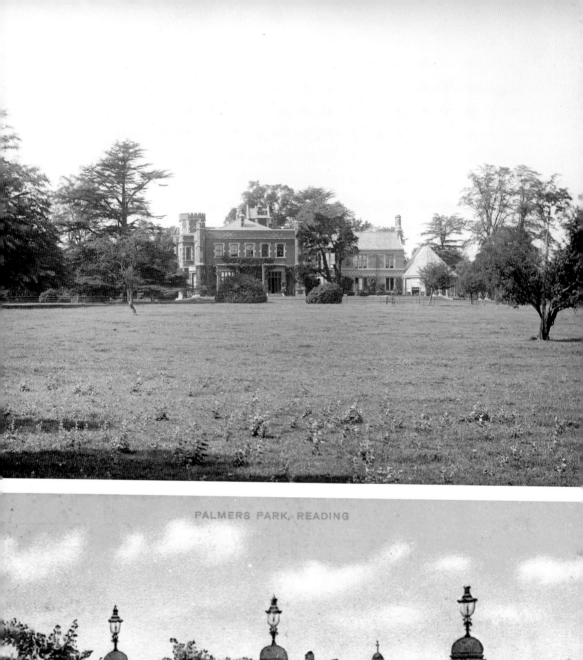

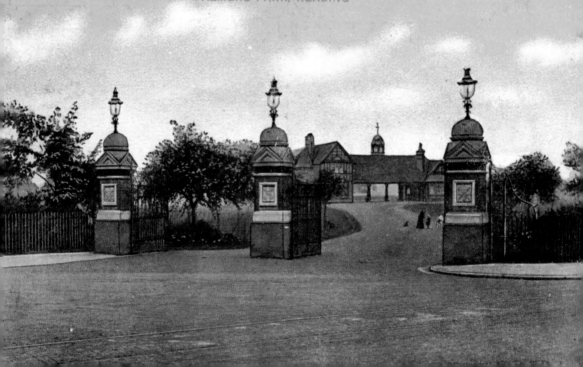

PALMERS PARK, READING

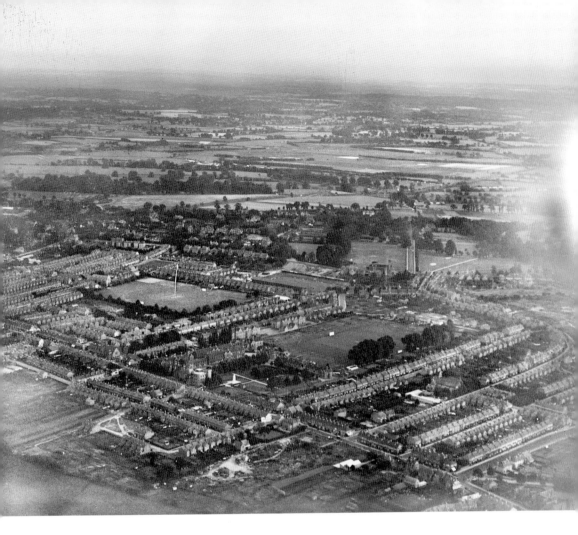

Opposite above: Whiteknights House
Henry W. Taunt's photo of 1890 shows the parkland leading to the Victorian Whiteknights House owned by the Duke of Marlborough. He bankrupted the estate and the house was demolished in 1840. (Historic England Archive)

Opposite below: Palmers Park
A colourful view of the entrance gates to Palmer Park. The original 21 acres of land were given to the town in 1889 by the proprietors of Huntley and Palmers' biscuit company. It was later extended to 49 acres, and opened in 1891. It was designed by William Ravenscroft. (Historic England Archive)

Above: Brock Barracks
An aerial view, taken in 1928, of Brock Barracks, the County Cricket and Elm Park Football grounds. The view is from the north-west of the town. The barracks were named after Major-General Sir Isaac Brock. Constructed in the Fortress Gothic Revival style, construction was complete in 1881. (© Historic England Archive. Aerofilms Collection)

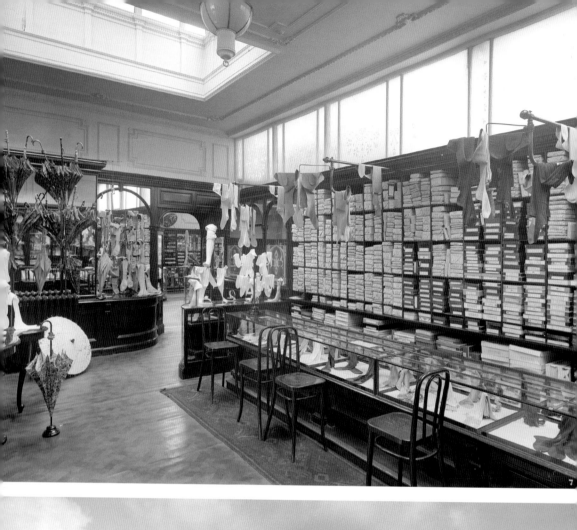

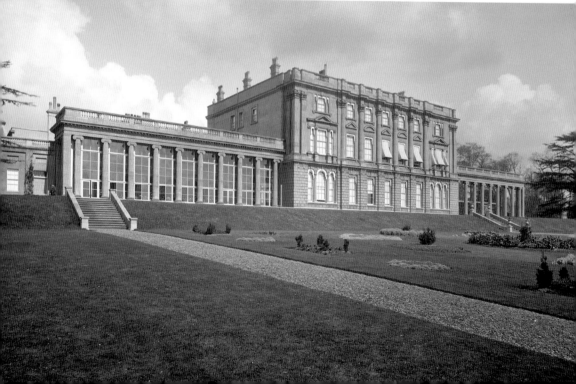

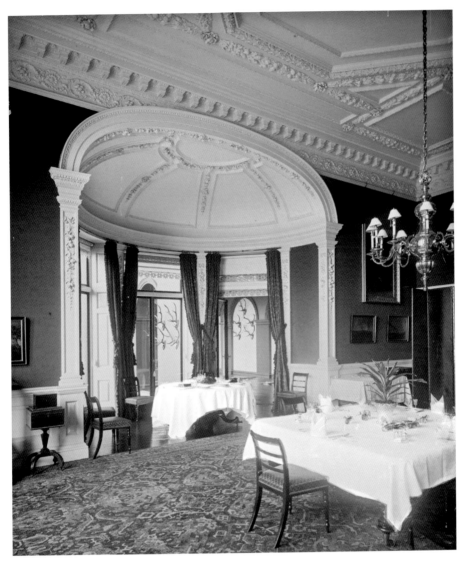

Opposite above: Wellsteeds Hosiery
This photo shows another view inside Wellsteeds hosiery department at Nos 126–133 Broad Street. (Historic England Archive)

Opposite below: Caversham Park
This view shows the front of the impressive Caversham Park that now houses BBC Radio Berkshire. This photo, taken in the nineteenth century, was commissioned by C. J. Crayshaw, the owner of the house, to show the work carried out by Horace Jones, who later designed London's Tower Bridge. (Historic England Archive)

Above: Caversham Park Dining Room
This photo was taken in April 1892 for the owner of the house, C. J. Crayshaw. It is of the dining room in Caversham Park, which was designed by C. E. Sayer. (Historic England Archive)

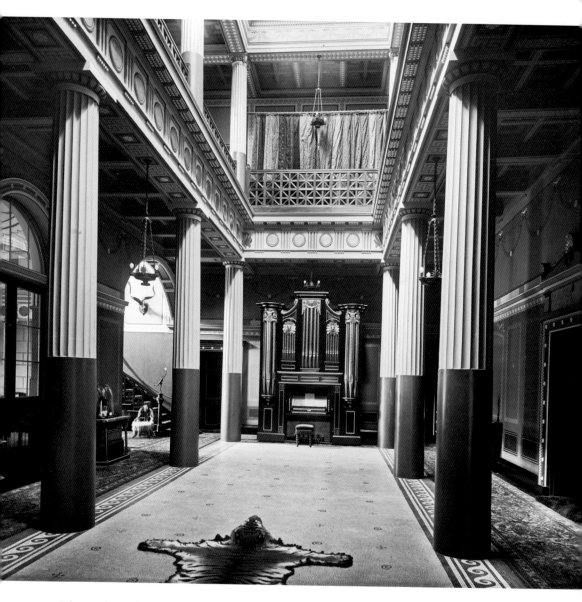

Salon at Caversham Park
This photo shows the salon at Caversham Park incorporating the impressive organ. (Historic England Archive)

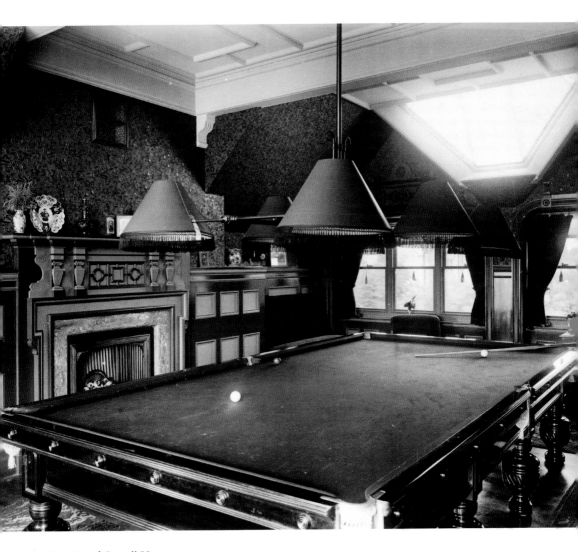

Interior of Orwell House
This photo, taken in 1888, shows the billiard room at Orwell House in Craven Road. The photographer was Owen Ridley, the owner of Orwell House. (Historic England Archive)

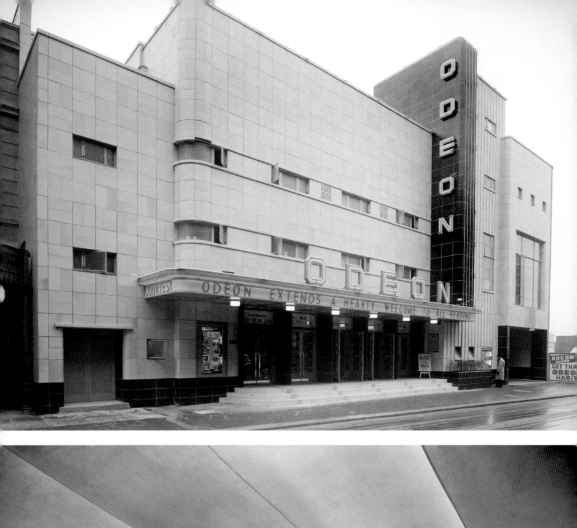

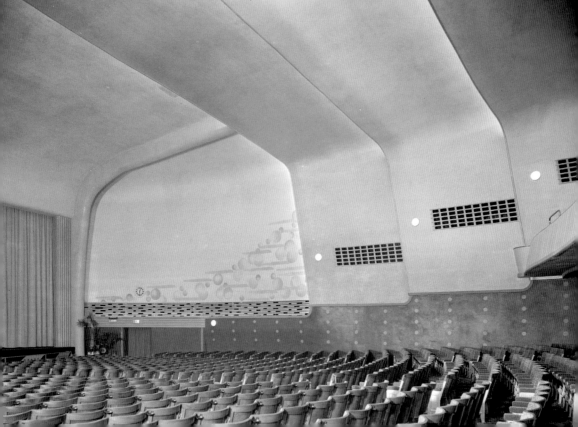

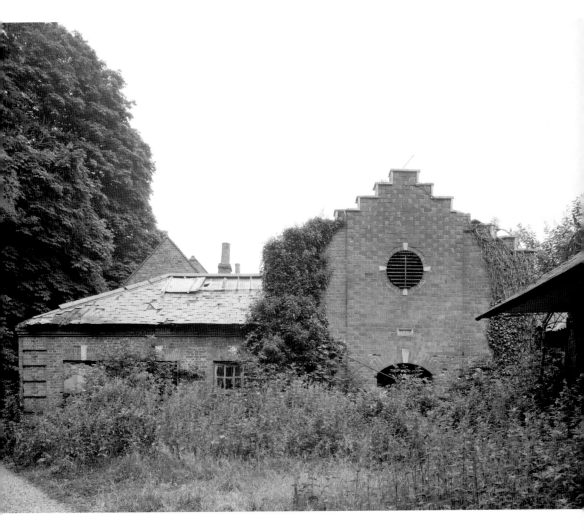

Opposite: Odeon Cinema
The first photo, taken by John Maltby in 1937, shows the exterior of the Odeon cinema in Cheapside. The second, taken by the same photographer, shows the spacious auditorium with the unusual side wall. (Historic England Archive)

Above: Coley Park Farm Laundry
This photo, taken by John Parkinson in 1983, shows the laundry at Coley Park Farm, which contains a number of listed buildings. (© Crown copyright. Historic England Archive.)

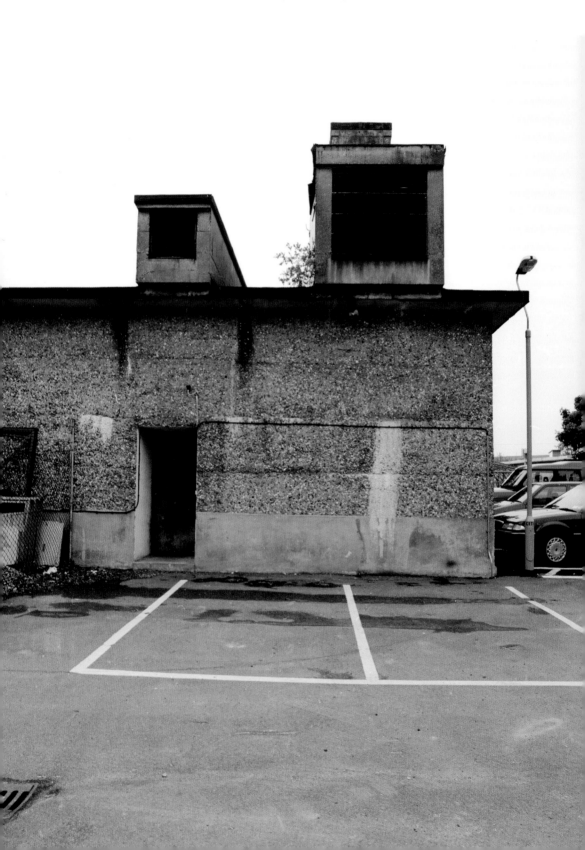

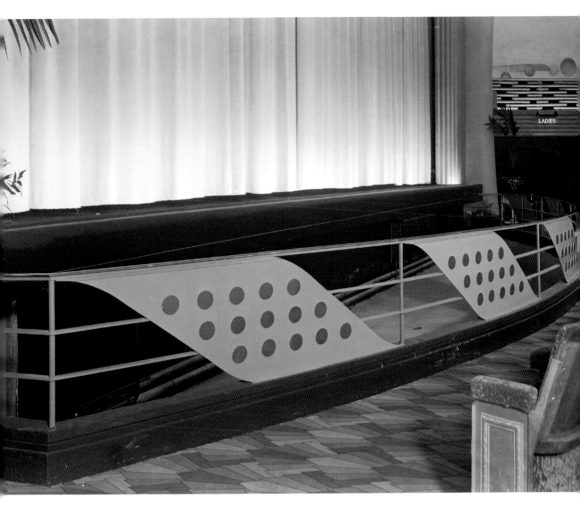

Opposite: War Room, University of Reading
This photo, taken in May 1998, shows the 'War Room' at The University of Reading on the Whiteknights Estate. This is a nuclear bunker dating from the years of the Cold War, and was built to coordinate civil defence in the event of an attack. The rather stark building is flanked by the inevitable cars on the left. (© Crown copyright. Historic England Archive.)

Above: Auditorium, Odeon Cinema
This photo, taken by John Maltby in May 1937, shows the front of the auditorium of the Odeon cinema in Cheapside. The main focus is the orchestra pit. (Historic England Archive)

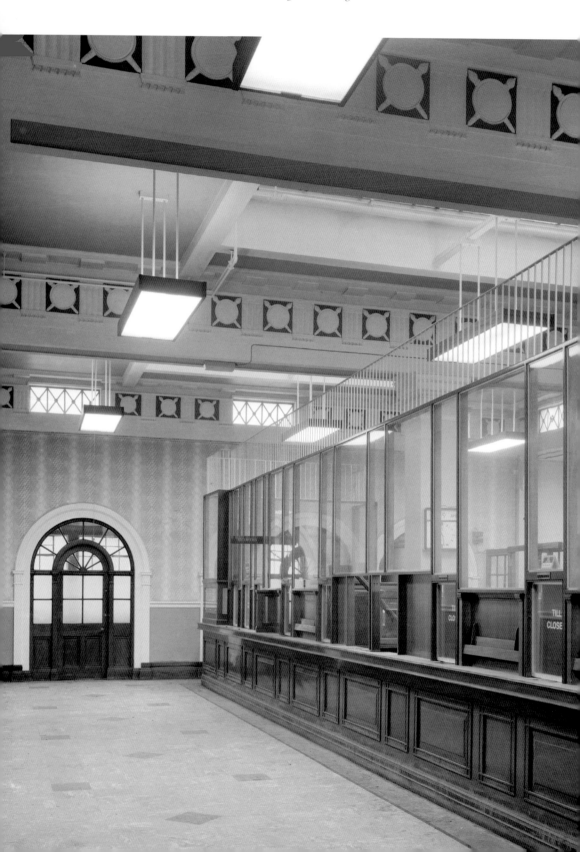

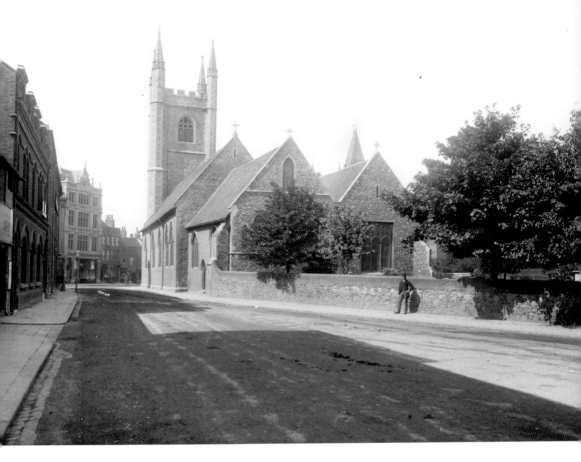

Opposite: Lloyds Bank
A bank had first been set up in Reading in 1790 by William Simonds of the brewing family. This photo, however, taken in April 1979 by Steve Cole, shows a more modern bank – the interior of Lloyds Bank in the Market Place. (© Crown copyright. Historic England Archive.)

Above: St Laurence's Church Tower
This photo, taken in the 1880s by Henry W. Taunt, shows Forebury Road, a wide street leading to St Laurence's Church. The tower, built in 1458, is still a landmark in the area. (Historic England Archive)

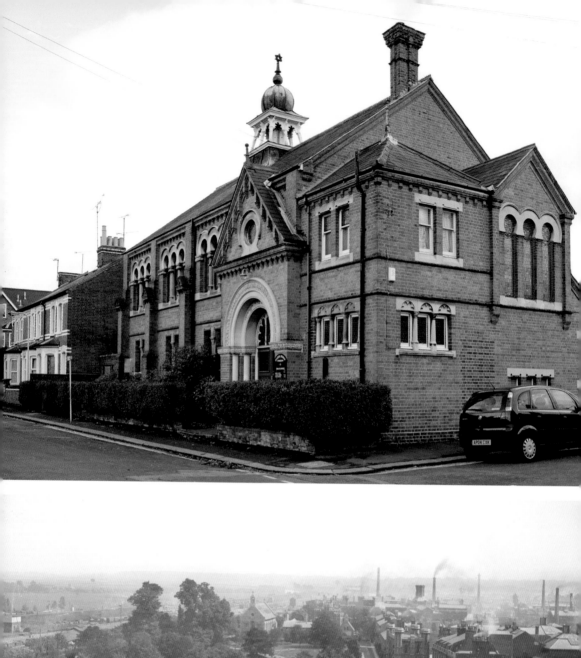

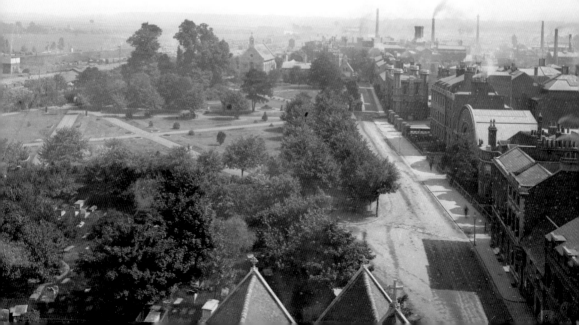

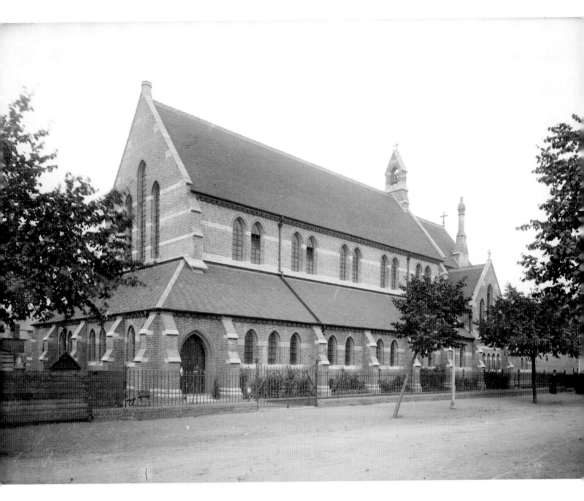

Opposite above: Hebrew Synagogue
This coloured photograph, taken by Peter Williams in December 2005, shows the building in Goldsmith Road where the Hebrew congregation meet. (© Historic England Archive)

Opposite below: Park and Factories
Photographer Henry W. Taunt took this photo in 1875 from the top of the tower of St Laurence's Church. It shows a panoramic view of the Forebury Gardens and a number of factories whose chimneys belch forth smoke into the grey sky. (Historic England Archive)

Above: St Luke's Church
This Victorian church, designed by J. P. St Aubyn, was built in 1882. There was an earlier St Luke's on the site, but a more permanent church was required. The photo shows St Luke's distinctive exterior from the south-west. It was consecrated by the Bishop of Oxford in 1883. (Historic England Archive)

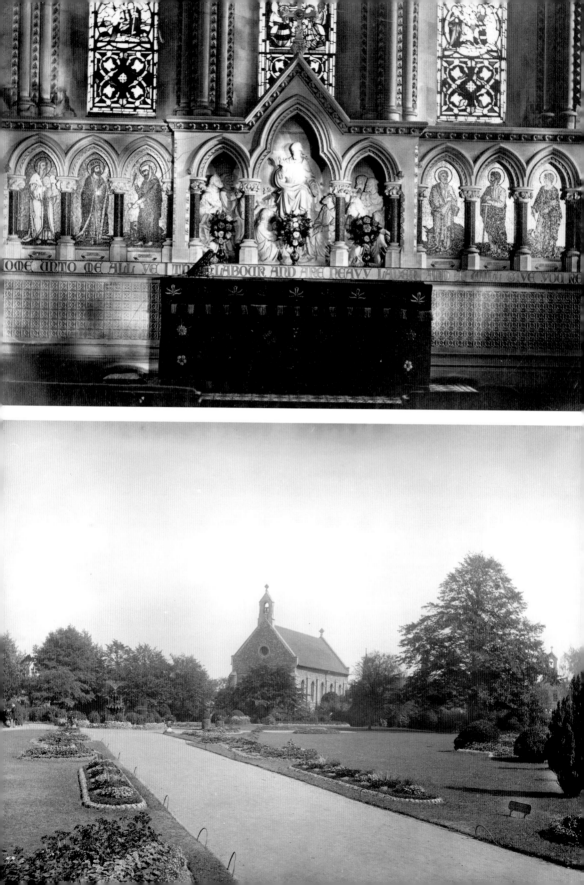

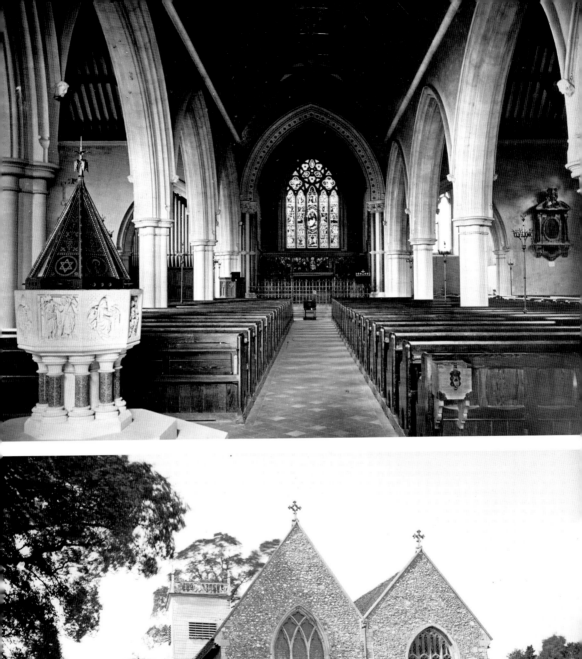
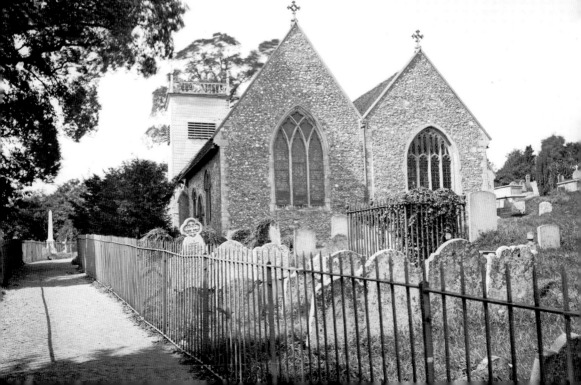

Previous spread, above left: The Church of St Mary Butts

This photograph, taken by Henry Taunt in 1875, shows a reredos depicting Christ and his disciples under a canopy at the east end of St Mary's Church. Although built during the Norman period only a single doorway survives. The reredos dates from a rebuilding of the east end that took place before 1853 and was replaced by the current reredos in 1935. The name St Mary Butts refers to the archery practice that used to take place here. (Historic England Archive)

Previous spread, below left: St James' Church

Set near the abbey ruins, St James' Church was designed by Pugin in the Norman style. Construction started in 1837 and it opened on 5 August 1840. The wide path leading to it is flanked by flower beds in Forbury Gardens. The church is a Grade II-listed building. (Historic England Archive)

Previous spread, above right: St Giles' Church

St Giles' Church was originally built in the thirteenth century. J. P. St Aubyn rebuilt most of it in 1873. However, the walls of the aisles, which can be seen in the photo, belong to the medieval church. Taken in 1875, the photo shows the font on the left and the main aisle leading to the chancel at the east end of the church. (Historic England Archive)

Previous spread, below right: St Peter's Church

St Peter's Church in Caversham was originally built in the thirteenth century. The photo, taken in 1875, shows the exterior of the church with the graveyard in the foreground behind railings. In 1878 a three-stage tower and a south aisle were added by Morris and Stallwood. (Historic England Archive)

Opposite above: Prospect House

This photo, taken in March 1942 by E. A. Kelteringham, shows an interior view of Prospect House situated in Prospect Park in Bath Road. The view is of the rear entrance hall showing the wide staircase. The Regency-style house was built in the eighteenth century by John Liebenrood and is Grade II listed. (Historic England Archive)

Opposite below: Orwell House

This photo, taken in July 1888, shows an exterior view of Orwell House in Craven Road. The spacious garden can be seen in the foreground. (Historic England Archive)

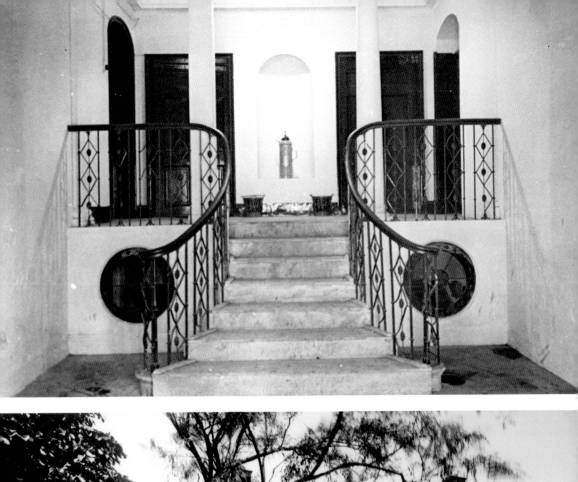

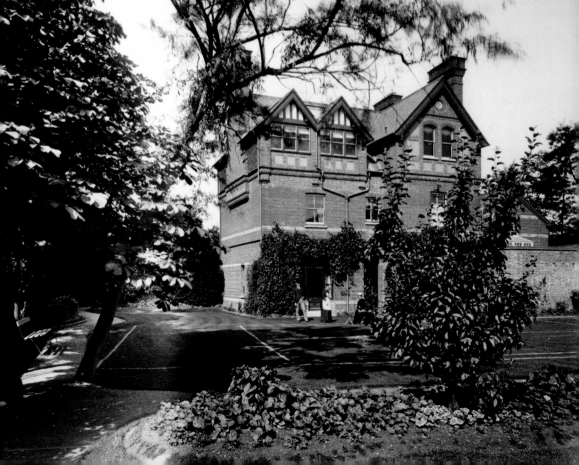

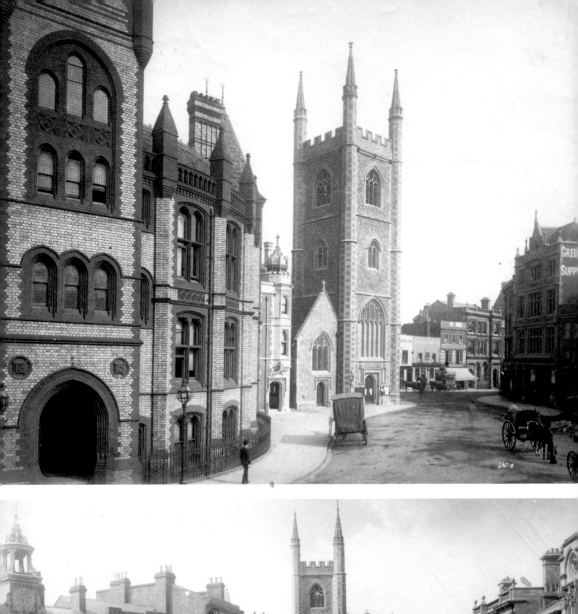
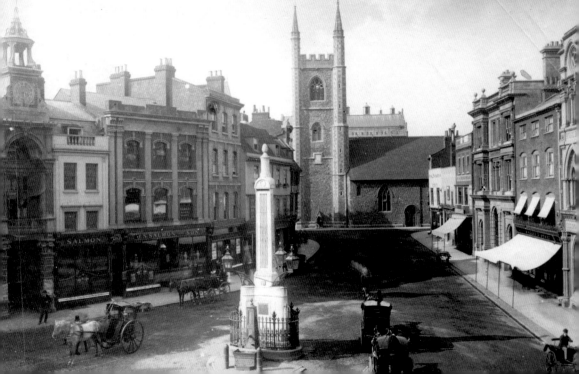

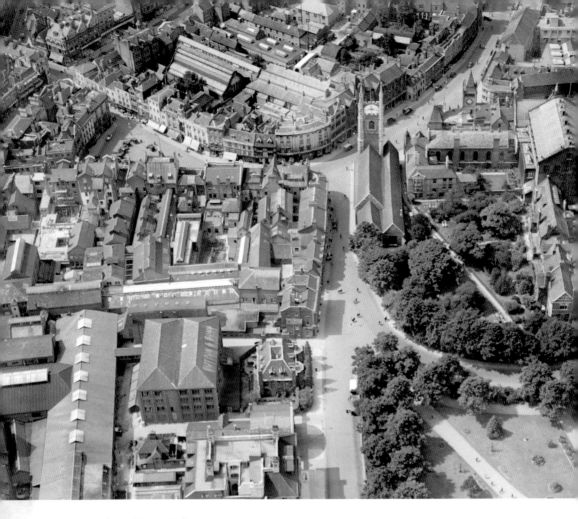

Opposite above: Town Hall
This photo, taken in 1875 by Henry W. Taunt, shows the Town Hall on the corner of Blagrave Street. Constructed in the Gothic style, they were designed by Waterhouse between 1872 and 1875. The tower of St Laurence's Church can be seen in the background. (Historic England Archive)

Opposite below: Simeon's Monument
This photo, taken in 1875 by Henry W. Taunt, has a closer view of the Simeon Monument, which was designed by Sir John Soane and constructed in 1804. Its triangular pillar is dwarfed by the twelfth-century St Laurence's Church standing in the background. (Historic England Archive)

Above: Aerial View of Reading
This aerial photo, taken in 1938, shows St Laurence's Church in the centre and Hutton & Sons Silversmith Works. (© Historic England Archive. Aerofilms Collection)

About the Archive

Many of the images in this volume come from the Historic England Archive, which holds over 12 million photographs, drawings, plans and documents covering England's archaeology, architecture, social and local history.

The photographic collections include prints from the earliest days of photography to today's high-resolution digital images. Subjects range from Neolithic flint mines and medieval churches to art deco cinemas and 1980s shopping centres. The collection is a vivid record both of buildings that are still part of everyday life – places of work, leisure and worship – and those lost long ago, surviving only in fragile prints or glass-plate negatives.

Six million aerial photographs offer a unique and fascinating view of the transformation of England's towns, cities, coast and countryside from 1919 onwards. Highlights include the pioneering photography of Aerofilms, and the comprehensive survey of England captured by the RAF after the Second World War.

Plans, drawings and reports provide further context and reconstruction artworks bring archaeological sites and historic buildings to life.

The collections are housed in a purpose-built, environmentally controlled store in Swindon, which provides the best conditions to preserve archive items for future generations to enjoy. You can search our catalogue online, see and buy copies of our images, as well as visiting our public search room by appointment.

Find out more about us at HistoricEngland.org.uk/Photos
email: archive@historicengland.org.uk
tel.: 01793 414600

The Historic England offices and archive store in Swindon from the air, 2007.